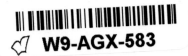 W9-AGX-583

Portraits of the Fifties

PORTRAITS
—OF— —THE—
FIFTIES

THE PHOTOGRAPHS
OF SANFORD ROTH

Text by Beulah Roth

with an Introduction by Aldous Huxley

Mercury House, Incorporated
San Francisco

Copyright © 1987 by Beulah Roth

The photograph of James Dean, © Seita Ohnishi, is used by permission.
The Introduction by Aldous Huxley was first printed in the brochure for
the exhibition *Sanford H. Roth: Fifty Contemporary Portraits* at the M. H.
de Young Memorial Museum, San Francisco, January 1 to February 1, 1953.
Reprinted by permission of the Huxley estate and The Fine Arts Museums
of San Francisco.

Published in the United States by
Mercury House
San Francisco, California

Distributed to the trade by
Kampmann & Company, Inc.
New York, New York

All rights reserved, including, without limitation, the right of the publisher to
sell directly to end users of this and other Mercury House books. No part of
this book may be reproduced in any form or by any electronic or mechanical
means, including information storage and retrieval systems, without permis-
sion in writing from the publisher, except by a reviewer who may quote brief
passages in a review.

Mercury House and colophon
are registered trademarks of
Mercury House, Incorporated

Manufactured in Hong Kong

Library of Congress Cataloging-in-Publication Data

Roth, Sanford, 1906–1962.
 Portraits of the fifties.

 1. Photography—Portraits. 2. Celebrities—Portraits. I. Roth, Beulah
Spigelgass. II. Title.
TR681.F3R68 1987 779′.2′0924 87–12152
ISBN 0-916515-29-X

Dedication

This book is an homage to my husband, Sandy,
and the twenty-five exciting years we shared

Contents

Acknowledgments

My thanks and gratitude to Dorris Halsey, my friend and literary agent, whose enthusiasm for the idea of this book ignited the flame that impelled Mercury House to publish it. To Alev Lytle, executive editor of Mercury House, a woman of inestimable charm and taste, who threw caution to the wind and influenced Mercury House to produce this book—to you, Alev, a deep "reverence." To the two Carols, Pitts and Costello, of Mercury House, for their endurance in working with a temperamental writer. To Zipporah Collins, whose ability for researching details is any author's gift from heaven. To Thom Dower, who designed this book, a gargantuan task, my appreciation for his talent and instincts. I cannot ignore my late brother, Leonard Spigelgass, who taught me how to come to the point and not to waste words. And much belated thanks to Miss Cora M. Barber, my English teacher at Erasmus Hall High School, who threatened me with torture on the Catherine wheel if I ever split an infinitive or dangled a participle.

A standing ovation for the cast of characters in this book, my "Friends, Romans, countrymen," who faced Sandy's cameras and became part of the history of the twentieth century.

Beulah Roth

Introduction

Photography is the art of catching the accidental revelation, of fixing the casual and momentary apocalypse. Even the worst photographer occasionally produces a good picture. By a stroke of mere good luck the most inept of us may click the shutter on an event whose shape upon the finished print is intrinsically meaningful, whose textures, tones, and contrasts possess the obscure but transcendental significance of beauty, and whose factual content is one of those infinitesimal cross-sections of time which the mind and eye are incapable of isolating, but which, when isolated by the camera, delight us by what they reveal of life's unfathomable strangeness and abundance. The bad photographer, when he deviates into sense, does so entirely by mistake; the good one, on the contrary, knows how to recognize the onset of a revelation and is able to foresee and take advantage of the apocalypses which life provides continually for those who have the eyes to see and cameras to catch and perpetuate.

Mr. Sanford Roth is one of the most gifted of these seizers of the proffered opportunity. With an uncanny eye for the harmonious pattern, the vividly odd or dramatic situation, he spots the approach of every happening which a camera can transform into a timeless and permanently pregnant moment. Thus, the subjects of his portraits are always caught at the precise instant when they are most completely themselves. We see Colette emerging from a rich twilight charged with suggestions of traditional France, while Nature in the form of a Siamese cat, sits aloof at the window, looking out at the pigeons. We see Stravinsky, bending in focused concentration over his music. We see Chagall—half glittering eye, half impenetrable darkness. We see Blaise Cendrars standing at the corner of a Parisian street, but looking like something on Easter Island. The records which Mr. Roth has left of places, animals, objects, and crowds are as highly charged with life as his portraits! In every case we feel that the flight of appearances has been arrested at the very crest of its multiple significance.

"Man," wrote William Blake, "has closed himself up, till he sees all things through the narrow chinks of his cavern." But we do not have to be short-sighted troglodytes. "If the doors of perception were cleansed, everything would appear to men as it is, infinite." Very few human beings achieve the permanent and completely transfiguring purification of heart, mind and eye; and even the artist's partial cleansing of his own and, through his works, of other people's perception is rare enough. To anyone who, by whatever means—through painting or philosophy, through poems or spiritual exercises or photography—contrives to enlarge the chinks of our self-imposed cavern, we owe a debt of profoundest gratitude.

Aldous Huxley
Los Angeles, California
November 1952

Traveling with Sandy

Born under the sign of Leo in 1906, Sandy was destined to be a rebel as well as a photographer. He grew up in the shadow of the Williamsburg Bridge in Brooklyn, which was then considered a spawning ground for gangsters and con men. While his classmates honed their skills in gambling, thievery, and truancy, Sandy learned photography. I lived in Brooklyn, too, and we knew one another as teenagers during the twenties.

Sandy's strict, upstanding family did not consider photography a respectable profession, and so, after graduating from New York University, he took a job as supervisor for a chain store company. Soon he was managing all the stores west of the Mississippi. This brought him to Los Angeles, where I had lived since my brother, playwright Leonard Spigelgass (*Majority of One*), had gone to work for Twentieth Century-Fox. Lenny and I considered anyone who wasn't in show business a "civilian." Sandy was definitely a civilian, but quite a wonderful one, and he and I were married in 1936.

Sandy climbed the executive ladder to a prestigious and highly paid position, but he hated every minute of it. The Dow Jones averages and the *Wall Street Journal* couldn't have interested him less; he devoted all his spare time to studying techniques of film processing. He had become the man in the gray flannel suit, but inwardly he was anti-establishment and determined to follow his instincts. In 1946 he quit his job by letter and freed himself to pursue his real passion—photography. His role model was Gauguin, who had left a prosperous life in France to pursue his art in Tahiti. Sandy and I took the opposite direction geographically, choosing Paris and *la vie bohème*.

The year was 1947, and postwar Paris was just beginning to recover from the German occupation. Sandy aimed his camera at the city, focusing on the unusual and the unexpected. A renaissance of art and creative thinking was taking place before our eyes—and before the lens of Sandy's camera. We documented Paris from Montmartre to Montparnasse, photographing Colette in her apartment, Picasso in his studio, Utrillo in Le Vésinet, Jean Cocteau, Georges Braque, and many others. This early work resulted in a book, *The French of Paris,* with a nostalgic text by Aldous Huxley.

Later Sandy became a special photographer to the film industry,

creating dramatic portraits and using his unobtrusive thirty-five-millimeter camera to record private moments offstage.

Those were exciting years, but my best memories are of Sanford Roth the man. He was, first and always, a city dweller. Since we were both from Brooklyn, our experience of mountains, flora, and fauna had been limited to views of Prospect Park. The only animals we knew personally were the milkman's horse, the neighbors' pet dogs and cats, the ubiquitous sparrows (who were as streetwise as we were), and the wild animals caged in the Prospect Park Zoo. All that changed when we first saw the Alps and the great forests of France. We developed a deep reverence for nature but were always a bit uneasy when we left the urban areas to climb those tortuous highways through the mountain passes. To us, real life was having pavement under our feet and a drugstore around the corner.

As a photographer Sandy was less interested in waterfalls, sunsets, and snow-capped mountains than in cityscapes, people, children, and animals. He loved faces. Sandy was fascinated by those of the important people he photographed, but then, he considered all people important: Africans in the Congo, muscle men in Santa Monica, and nuns in Rome.

He was always impatient to develop his negatives. In Paris we lived in a small hotel, the Lutèce on the Rue Jules Chaplain in Montparnasse. Sandy would perform the ritual of removing his film from the camera in a changing bag, and then in a primitive way, like an ancient alchemist, mix his solutions in a portable developing tank. He hung the finished negatives up to dry in the bathroom, using string and paper clips. The developing tank and the film reels were then rinsed off carefully and left to drain in the bidet. The maid was no doubt mystified by all this paraphernalia and by what she probably considered *outré* American sexual practices.

In addition to photography and cats, whom he adored in any and all forms, Sandy had a passion for bicycling. As a youth, he had dreamed of taking part in the Six Day races. When a well-known manager approached Sandy's father with this idea, Sandy's prized Bianchi machine was taken from him within five minutes and his father warned, "No son of mine is going to be a bicycle bum. You go to college!"

Years later, his love of bicycles and racing was nurtured in Paris. We attended every Six Day race in the velodrome and followed the Tour de France. We even got to know the famous Six Day racer, Oscar Egg, who had a bicycle shop on the Avenue de la Grande Armée. Oscar Egg was Belgian. He spoke little English and Sandy spoke even less French, but their mutual love of bicycling overcame all linguistic problems. They rhapsodized for hours about saddle seats, spokes, sprockets, chains, Bianchis versus Peugeots, and the old days in Madison Square Garden when Egg was the champion and Sandy a sixteen-year-old fan—in some language they both seemed to know but that sounded like Sanskrit to me!

Sandy was also a great lover of antiques. Every Saturday, Sunday, and Monday morning, we were up at dawn to haunt the flea markets. He was particularly intrigued by Roman antiquities, Gallé glass, Bru dolls, old fabrics, and African masks and tribal artifacts.

Clothes were another of Sandy's loves. He preferred casual but very expensive attire: shoes made by Lobb in London, tweed coats tailored by Hawes and Curtis in Savile Row, and blue shirts from Brooks Brothers. When we were first married, I learned from a Brooks Brothers salesman how to iron them a special way. Sandy hated laundries because they ignored instructions to omit starch and sent his shirts back in what he considered a deplorable condition. To keep peace, at home I did the laundering and ironing, a gesture and talent I regretted for years. But in Paris and Rome they had to be given to a laundry, so we attached large notes to the collars: *"Pas d'amidon!"* and *"Sensa amido!"* Sometimes it worked, and sometimes it didn't. Rome was, among other things, a city of men's shirts. At last Sandy succumbed to the marvelous selection and transferred his allegiance from Brooks Brothers to Cerutti.

I usually accompanied Sandy on his photographic forays, serving as informal assistant, secretary, and translator. I have many wonderful memories of those sessions. The following are some of them.

The worst of times were over; the best of times were beginning. That's how we felt, those of us who flocked to Paris after World War II. The fighting had ended; creative thinkers and artists began to emerge once more after a long hibernation. Postwar Paris became a mecca for the painter, the poet, the composer, the philosopher, and even the photographer. In that special time and place, Sandy began the work in portrait photography that he loved so much, and we met a fascinating group of people, many of whom would become lifelong friends.

We arrived in Paris from Los Angeles in 1947. The first years were difficult financially, but our time was not wasted. We explored the city on foot, using Sandy's small, unobtrusive thirty-five-millimeter camera to document her character, people, places, animals, cafés, markets, and everyday life. We wanted to hold a stethoscope to the heartbeat of the city, to become her confidante. What we needed was a guide, and we found one in the charming Lithuanian-French-American painter, Arbit Blatas, whom we met through a friend. Arbit was more than a talented artist; he had a natural gift for making

friends easily—and keeping them. Everyone seemed to know him, and everyone obviously liked him. He was part of the elite Montparnasse enclave that came together in the Café Flore, Le Dôme, and La Coupole.

One day, Blatas and our mutual friend, art dealer Jean Mathey, suggested that my husband might like to photograph Maurice Utrillo. Utrillo, renowned for his paintings of Montmartre, was now living far from the beloved Montmartroise neighborhoods of his youth, in a chic pink villa in Le Vésinet. This was not too far from Paris, but far enough to keep Utrillo at home under the watchful eye of his wife, Lucie Valore. Utrillo was an alcoholic, and she did not trust him to roam the streets and cafés of Paris without succumbing to his *petit vin blanc*. Utrillo seemed consumed by his former life in Montmartre, and his paintings were now based on memories of that happier time. I think Sandy's photographs catch the sadness that shadowed Utrillo's face and betrayed his dislike for the life he was forced to live.

We came to know Utrillo well and photographed not only his work but also the little chapel where he lit votive candles to his patron saint, Joan of Arc. We also became good friends with his white Pekingese dogs and his family of cats and kittens. Sandy's photographs of Utrillo were bought by *Look* magazine, and my husband was finally a professional photographer.

We began to meet and photograph other artists and creative thinkers—Colette, Cocteau, Léger, Vlaminck, and Braque—but my memories of Picasso are among the most vivid. Being in Picasso's presence reminded me of something the White Queen said in *Alice in Wonderland*: "Think of six impossible things to do before breakfast." Our meeting with Picasso wasn't before breakfast, but it certainly would have made a list of six things I never expected to do. I stood before him, seeing not merely a name in an art book, an abstraction, but a man of substance. He was not only a genius, but also a man of acerbic wit and earthy humor. He demonstrated his acute power of observation that day by the comments he made on my husband's photographs of his colleagues: Léger, he said, looked like a concierge. Vlaminck, a peasant. Braque, a banker. Cocteau, a genius. And Colette, a woman who had lived.

We became frequent visitors to Picasso's studio on Rue des Grands Augustins. He liked us very much, but, more importantly, so did Jaime Sabartés, his friend/secretary/watchdog, who could adopt the temperament of a Doberman pinscher when protecting Picasso from visitors. After a bit of subliminal flirting, Picasso took me up to the roof of his studio to see his collection of beautiful white doves— the emblem of peace that appears in so many of his drawings, posters, and ceramic pieces. While we were up there, he pinched me on the derriere.

Our cat, Louis, came with us quite often, at Picasso's request. He adored cats and showed me many of his cat sculptures, which, as far as I know, have never been exhibited. He was also fond of owls, goats, and the entire human race. One day while we were in the

studio, Picasso suggested that we take Louis off his leash and let him wander. Louis explored every available corner, then suddenly was gone. The search began. Picasso, Sabartés, Sandy, and I could find no trace of our cat. Terrible thoughts ran through my mind. Had he found his way to the roof and devoured some doves? Was there a hole somewhere in a wall that would lead him to the sewers of Paris? Suddenly, Sabartés screamed, *"Voilà!"* He had moved a chest of drawers, and there was Louis crouched in a nest of dust curls, at least twenty years' worth. But the *"Voilà"* was not for Louis, it was for a notebook of Picasso's that had been missing for years. Now when I read of the exhibition of *Je Suis le Cahier* of Picasso I wonder whether my cat Louis had something to do with their discovery.

Noel Coward was a good friend of my brother, Lenny. I knew him quite well, too, and remembered every song and lyric he had written. The day Sandy photographed him at the CBS Studio in Hollywood, Noel was in Los Angeles to appear in and direct the television production of his play, *Blithe Spirit.* We saw Noel between scenes, and Sandy said, "Noel stand just where you are." Sandy pointed his little Nikon at him.

"But what shall I do?" Noel asked.

"Nothing," said Sandy. "Or if it makes you happy, sing 'Don't Put Your Daughter on the Stage, Mrs. Worthington.' "

"Good God," said Noel, "I've forgotten the bloody lyrics!"

I told him I knew them and then prompted him through verse and chorus.

"By the way," he added as we left, "you wouldn't happen to know the third verse of 'Stately Homes,' darling?"

As a matter of fact, I did.

Noel Coward told me of a wonderful, but possibly fictitious, exchange he had with Edith Sitwell. Sir Noel and Dame Edith were guests at a cocktail party in London. Noticing the spectacular jewelry Dame Edith wore—massive gold bracelets and a topaz ring of about forty carats—Noel remarked how much he admired the bracelets. "Cartier?" he asked.

"No, dear boy," she answered, "Cellini!"

If Noel had meant to flatter her by mentioning the famous jeweler, she had outdone him with her allusion to the Renaissance goldsmith, who had crafted her bracelets himself.

Aldous Huxley brought Dame Edith to our house for tea one day, because Sandy was to photograph her. To make the occasion more or less casual, I decided to serve a British tea of scones, crumpets, Madeira cake, and cucumber sandwiches—not forgetting the milk and demerara sugar.

Dame Edith was quite majestic in her manner and attire—a Medici turban and the famous massive jewelry. Of course, I was impressed by her presence. Actually, impressed is not the word. I was overwhelmed to have my muse of poetry sitting on my own sofa. But, as I approached with her tea and a tray of those cakes, tarts, and sandwiches, she aimed one of her well-known barbs at me.

"My dear," she declared with a *soupçon* of *noblesse oblige,* "I

drink my tea. I don't eat it!"

The striking portrait of Edith Sitwell photographed that day appeared in *Harper's Bazaar*—a full page. I am sure Dame Edith approved. Both the portrait and the magazine were within her sphere of elegance.

Aldous Huxley became our very good friend and collaborator under strange circumstances. The book we intended to do on Paris was almost completed but it needed a text, which we hoped Jean Cocteau would write. He declined, and for a very valid reason: He was too close to Paris, he said. He loved the city so much that he might overlook her shortcomings. Cocteau suggested that the text should be done by someone who was *not* French.

One evening at a party in Santa Monica, California, we brought up the subject of the text. A charming lady with a slight foreign accent had a suggestion.

"I think my son-in-law could do it well."

Her son-in-law? Who was that? I suppose everyone else in the room knew, but Sandy and I had no idea.

"Give me your telephone number and I will ask him to call you in the morning," she continued.

Exactly at nine the next morning, our telephone rang. When I answered, a man with a rather high-pitched voice and an unmistakably British accent asked for my husband.

"May I ask who is calling?"

"Yes," the voice said, "just say that it is Aldous Huxley."

I couldn't believe what I was hearing. This was her son-in-law? Of course it was. I remembered then that the *grande dame*'s name was Madame Nys and that her daughter, Maria, was married to Aldous Huxley.

Aldous was very excited by the idea of doing a text on Paris. He would write about his memories of the city as a youth. He chose the title, a quotation from Chaucer that contained the words "the French of Paris." It was apt, because the French of Paris consisted of nationals from all over the world—Lithuania, Spain, Romania, Russia, and even America—and each added secret ingredients to the French culture.

Aldous's text was wonderful, but we were also learning to appreciate the man himself. He had, in our opinion, one of the most versatile minds of any writer in the twentieth century. We loved his sense of humor, his appreciation of the ridiculous as well as the sublime, his ability to laugh at human frailties. Aldous gave us the future with *Brave New World,* but he also loved to have fun. It was he who discovered that the "toadstools" that sprang up at dawn on Jack Benny's lawn in Beverly Hills were not poisonous at all but a delicate variety of mushroom as delicious as any Huxley had ever eaten. Yes, I ate them, and I am still here to tell the tale.

Aldous Huxley introduced us to Igor Stravinsky. Stravinsky was a small man who smoked long Russian cigarettes in a holder. One day

I couldn't help noticing that he cut off more than an inch of each cigarette before fitting it into the holder. He explained that the shortened cigarette added to his height, whereas a longer one would diminish his stature. That was typical Stravinsky. Who else but he would have had a large sponge mounted as a sculpture because it looked like the head of Beethoven?

Huxley was over six feet tall; the diminutive Stravinsky's measurements are not on record. They weren't exactly a matched pair, but they were good friends and were both part of the exciting group of intellectuals who lived in Los Angeles during the fifties. You never knew whom you would meet at the Huxleys. It might be Dr. Edwin Hubble, the great astronomer, or screenwriter Anita Loos, or Frieda Lawrence (the original Lady Chatterly), or the Stravinskys.

To celebrate Stravinsky's seventy-fifth birthday, *Harper's Bazaar* asked Sandy to do a full-page portrait of him, and Stravinsky invited us to invade his *sanctum sanctorum*. The light was so bad that day that we had to do a little set dressing and asked Stravinsky to continue with his work on a wooden terrace in back of his house on Wetherly Drive in West Hollywood. His head was bent over his manuscript and he seemed to be concentrating on a passage when suddenly he murmured, "Roth, hurry it up. The termites out here are working faster than you are."

A few years later in Paris, Stravinsky and Jean Cocteau were collaborating on a production of *Oedipus Rex*. George Balanchine and some dancers from the New York City Ballet were on hand to interpret Stravinsky's music in costumes designed by Cocteau. Sandy thought it might be a nice idea to photograph Stravinsky and Cocteau together. They agreed, but they never seemed to be at the Théâtre des Champs Élysées at the same time. There was Jean Cocteau, but where was Stravinsky?

"Stravinsky was hungry," said Cocteau. "He left for lunch."

We waited, and eventually Stravinsky arrived. But where was Cocteau?

"He was hungry," said Stravinsky. "He left for lunch."

At four o'clock they both appeared backstage and *voilà*, the wonderful photograph of these two multi-talented men was taken.

My husband did not speak or understand a word of French. (Well, perhaps he had mastered three or four. He could say *bonjour* and *bonsoir,* and he understood *droit* and *gauche*.) Therefore, the responsibility for all conversation conducted in French rested with me. My French was not bad, but the repartee I had learned at Erasmus Hall High School in Brooklyn did me about as much good as a course in Hindustani. The French I spoke in Paris I learned by ear. I guess it was street French, but I was fluent, and that was lucky because *nobody* we photographed in France spoke English. I suddenly found myself in the role of social secretary, researcher, appointment clerk, film carrier, and map reader for both city streets and country roads. I was embarrassed at times by my strange accent, but Jean Cocteau encouraged me to speak, accent or not. He assured me that anyone who was not Parisian had an accent. He cited the Provence accent, the Marseilles accent, the Spanish accents of Picasso and Miró, the Bourgogne accent of Colette. He really buttressed my ego, and I thought how proud my high school French teacher, Monsieur Delatreppe, would have been of his tongue-tied pupil.

Cocteau became a dear friend. I have countless letters from him, always with a notation on the back of the envelope reminding me to embrace my cat, Louis, for him. Jean Cocteau was a passionate cat lover and was elected President of the Cat Club of France, an honor I am sure meant more to him than being a member of the Académie Française. Once he used his prestige, something he rarely did, to change a French law for our benefit. I was about to leave Los Angeles for Paris when I learned that a new law had been passed prohibiting the entry into France of any carnivorous four-legged domestic animal. The purpose was to prevent a nationwide epidemic of rabies. Sandy asked Jean Cocteau to intervene. In response, Cocteau apparently stood before the French legislature and told them about American vaccinations against rabies. Since the rabies vaccine had originated in France with the scientific research of Dr. Pasteur, Cocteau insisted that the law be changed—*at once!* The legislature listened to Cocteau, thought the whole thing over, and agreed. Louis and I got the next sailing of the *Liberté*—and a four-page story in *Paris Match*.

I have found that the intellectuals of the world are generally pro-cat. They may differ in their opinions on impressionism, dadaism, cubism, dialectics, James Joyce, and women, but their love and respect for cats seem to be unanimous. To the French, the cat—a non-conformist, a revolutionary, and an intransigent—is the symbol of *"Liberté, Égalité, Fraternité."* So in France the cat continues to purr contentedly on the painter's easel, the poet's knee, and the writer's table.

Now we come to Colette, who was a royal personage to cats. She might have been elected an honorary cat, so well did she speak their language.

I first saw Colette quite by accident one day as I was strolling through the Palais Royale gardens. I glanced up at a window in the upper floor of a building, and there, leaning on a brilliant pink silk cushion, was the unmistakable face of Colette. She smiled at me, but I walked away, not wanting to intrude on her privacy. Later in the day, I thought about the opportunity I had missed to meet this remarkable woman. I threw timidity and caution to the wind and wrote her a note. It was not an ordinary note. I told her about the book we were doing on Paris and said that without her it would be incomplete. But I saved the best for last: I asked permission to bring our cat to visit. The letter was sent by *pneumatique*, that mysterious Parisian system of expediting mail through a series of compressed air tubes underground. It cost less than a telegram and more than ordinary postage, but was well worth that extra franc.

Colette's response arrived the next morning by *pneumatique*. Written in her own hand on her famous blue notepaper was an invitation to come to see her as soon as possible. She also asked me to telephone her at Gutenberg 6136 and, above all, "Do not forget the cat."

We arrived at her apartment the following day with Louis in a champagne basket and the champagne in my arms. My husband brought her a box of his photographs to see. Before we reached the door of her apartment on Rue de Beaujolais, we heard Pauline, her housekeeper, friend, and constant companion, say, "Madame, they are here!"

Then Colette's husky voice asked, "Is the *cat* with them?"

When we entered her study, she was reclining on a chaise longue with her writing table over her knees. It was littered with manuscripts, inkpots, a wine bottle and glasses, and a single beautiful rose in a small vase.

Pauline moved the writing table over a little, and I deposited the basket on her lap. She opened the lid and there was Louis. Colette was speechless for a moment. She stared at him, appraised his coloration, and then spoke to him.

"Monsieur, how well dressed you are!" She purred to him, and he understood. She meowed at him, and he understood. She embraced him with all the love she reserved for cats, but this time Louis did not understand. A pigeon had alighted on Colette's windowsill, and Louis asked for freedom. Now it was Colette's turn not to understand. As her grasp became tighter, Louis, being a cat, defended himself by scratching Colette's arm. The earth quaked under me, the sky fell, and I found myself developing a hate for this creature I loved. Sandy and I could not even apologize. What kind of apology would be appropriate for such a feline social gaffe?

A day later Colette herself showed the way. She was interviewed for an article in *Les Arts*. She began by talking about the memorable visit she'd had from an American cat. She described the scratching incident and then made the following admission: "I hereby apologize to the cat publicly. I should have known better than to hold him against his will. It is I who am guilty, *not he!*"

The photographs Sandy took of Colette that day have been published all over the world. Included is the infamous moment of cat versus human.

Almost every painter we photographed in Paris was an ailurophile (cat lover), but Leonor Fini was an ailurophile of the four-star variety. Like Sandy and me, Fini was born under the sign of Leo, the Lion. This gives us a feline disposition and a mystical reverence for all the cat family. Leonor used the cat, or the abstract form of the cat, in many of her paintings. She herself had a rather feline quality. The day Sandy photographed her, we knew there was a cat litter box lurking somewhere, a fact that disturbed neither Leonor nor us.

Leonor was wearing a magnificent yet curious dress that resembled an Austrian windowshade: It was made of shirred black silk taffeta with bits of brilliant yellow at the edges of the sleeves. My eyes absorbed every detail and silently I asked myself, "Where?"

With that feline ability to read minds, Leonor answered aloud, "Schiaparelli."

I still remember it as a fine example of surrealistic couture.

A few people are neither cat lovers nor cat haters; they have no opinion on the subject. Georges Braque was one of them. Sandy had photographed him in Paris a year or two earlier, and we were on our way to his studio in Varengeville in Normandy for another sitting. It was raining when we left Paris and our Citroën suffered, like all other cars in Paris, from wet spark plugs that refused to ignite after being on the street all night. The nearest garage in Montparnasse was so inundated with calls that help did not arrive for an hour. This wouldn't have been a serious problem if our appointment with Braque had not been for eleven o'clock that morning. I knew that Braque was very particular about time. To his mind, there was no excuse for tardiness. We were already late, but couldn't stand the thought of leaving our cat alone in a hotel room for the entire day, so we ran upstairs to get Louis, put him in the car, and finally left Paris. The rain-soaked trip to Varengeville took longer than expected— nearly three hours. Our schedule had been upset, and we suspected that Braque would be, too.

Sandy appointed me apologizer, warning me to put some feminine sobs and hand-wringing into my explanation. I rang Braque's bell, and he appeared, napkin around his neck and fork holding a piece of *ragoût* in his hand. He was angry, no doubt about that, and literally ordered us into the village to have our own lunch while he finished his. An omelet and a glass of wine later, we returned, and Braque grudgingly asked us into his studio. The rain was heavier than ever and the thought of leaving that meowing creature in the Citroën prompted me to ask Monsieur Braque if it would be possible to take our cat indoors with us.

"A *cat?*" he shrieked. "No, it is not possible!"

At that moment, Madame Braque appeared and said something to her husband that changed his mind. (French wives can do that.)

"Well," said Braque, "bring him."

At first Braque glared at Louis as though he were a prehistoric saber-toothed tiger, but then suddenly his eyes brightened and his entire attitude changed. "That cat, he is wearing Braque colors!"

In another moment Louis had jumped on Braque's work table. Out of the corner of my eye, I saw Braque tickling Louis with a paintbrush. Sandy photographed that, you can be sure. I think Braque became one of *us* after that encounter of the feline kind.

One evening in Rome, we were having a drink at the Café Rosati with a group of friends that included writer Alberto Moravia. Mr. Moravia claimed to know more about Siamese cats than anyone else. I admired him for his astute observations on cats—especially my cat, who sat on one of the Rosati chairs listening intently to Moravia's views. Said Moravia, "I intend to tease your cat, and I assure you there will be no reaction from him."

I wanted to tell him that he was wrong, very wrong. He proceeded to snap his fingers under Louis's chin, and there was no reaction for

the moment, other than perhaps boredom. I gave Moravia four more seconds to complete his experiment when I heard a warning signal go off in Louis's throat. Then, in a flash, Louis had Moravia's wrist in his mouth, sinking felines (I cannot say "canines") into his flesh. It wasn't a very serious bite, but Moravia was petrified. The waiter offered cognac to wash the wound, but Moravia wanted only one thing. "Take me to the nearest hospital," he said with all the authority at his command. "I must have penicillin." I applaud Moravia for his writings, which are superb, but I think he knows much more about human behavior than cats'.

When we photographed Carlo Levi in Rome, I had no idea that he was not only a prolific writer and an excellent painter but also a physician. His book *Christ Stopped at Eboli* documents the years he was exiled from Rome by the Nazis to a little mountain village north of Naples. In it he tells of his influence on Eboli and Eboli's influence on him. The book stresses that friendships between people of diverse backgrounds can be lasting and profound.

Carlo Levi had a strange pet, as you can see in the photograph of him in this book. His constant companion in his studio was a crow. The wild creature, which he had brought from Eboli, soon became urbanized and Roman enough to eat pasta and take an occasional sip of chianti.

Levi's apartment/studio was in an ancient palace, the Palazzo Gesù. He occupied the top floor. It was literally filled to the rafters with newspapers, books, canvases, and the other impedimenta of a collector. I tried to envision the day when he would be obliged to move.

That day came very soon. The building was to be remodeled, and Carlo Levi's apartment would be the first to go. He received a notice but paid no attention to it until he faced imminent eviction. All of Rome, friends and enemies alike, threw polemics aside and sent out calls for help to find Carlo Levi a studio. Newspapers printed the request; word of mouth spread the news from Piazza del Popolo to Via Veneto. There were no vacancies anywhere that filled his needs, and the situation seemed grim indeed until our housekeeper, Magdalena, solved his problem. There is no doubt that Magdalena was nosy and gossipy. She spent her free moments (which were many) leaning out of a window in our apartment on Via di Villa Ruffo.

"I found one," she announced one day, "the perfect studio for Monsieur Levi!" Magdalena was breathless with excitement. "It's right up the hill from us, and it's vacant."

"How do you know about it?" I asked.

"As I was leaning out the window this morning, I saw a hearse go up the hill and then come down again. That meant that somebody had died. I did a little investigation and discovered that the man who was dead hanged himself. He was a poet, Madame, so I thought it would be a perfect place for Monsieur Levi."

Actually, it was. We waited until all the belongings of the deceased had been removed, and then, with the help of a few of Levi's friends, we notified him of our discovery. We all made a vow not to mention the fact that a man had hanged himself on the premises. Fortunately, the identity of the poet was unknown to us and Carlo Levi believed our improvisation about an old lady who had had to move to Florence to live with her daughter. He shed a tear or two and then moved in with his paraphernalia and lived there happily until the day he died.

Sandy and I were fascinated by the metaphysical school of painters, most of whom were still living in Milan. We believed these aging masters should be photographed for posterity. We drove to Milan for a weekend and in those few days found Carlo Carra, Mario Sironi, and a few others, but we missed Giorgio de Chiricho, who was the most acclaimed and widely known of the group. He lived in Rome, not far from the Spanish Steps, but was, at the time, in Venice, supposedly participating in the Biennalle. Actually, he was not participating at all, but rather denouncing the committee, and even his own paintings, those metaphysical constructions of endless arches, pink horses, pyramids, and vanishing points that do not vanish. He presented an exclusive exhibition of his new approach to art, which to us seemed as old as the hills: a little Rembrandt, a bit of Titian, a lot of Rubens, all matted on red velvet and framed in carved gold leaf. Some of his old paintings were hung too, but de Chiricho refused to let us photograph him near them. He seemed to be having a serious argument with himself about his old theories. His new theory carried the day with him, but the art world laughed and still associates de Chiricho with his earlier work. I don't think he ever knew what giggles his new, grandiose style provoked. Mine among them!

It was Ashley Montagu, the cultural anthropologist, who arranged for Sandy to photograph Albert Einstein at Princeton. Sandy always considered his meeting with Professor Einstein one of the greatest moments of his life. I can understand his enthusiasm now, but at the time I was disappointed because I was not encouraged to go along. I thought, "This is some kind of intellectual stag party. No women allowed!" Of course, that was not the case. Dr. Montagu intended to have a grave conversation with the professor while Sandy photographed the great man. Before they began, I was told, Professor Einstein cautioned Sandy to take no more than six pictures. Three hours passed as Montagu and Einstein had a lengthy discussion about nuclear power and the world, with Sandy focusing his camera directly on them. Finally Einstein turned to Sandy and said, "Roth, you are a naughty boy. You took more than six!"

"Yes, I did," said Sandy, "but, Professor, you should know that in order to get six good ones I had to take one hundred."

Sandy was expecting Einstein's wrath. Instead, he got the response, "You are right, Roth. It figures mathematically."

A dear friend, Dr. Sonia Dubkovitch, asked us to lunch one day at her apartment. "There will be someone else I think you would like to meet." When we arrived, the other guest was already there. She was a lady "of a certain age," rather plain and drab in a black dress. She wore no makeup of any kind but had the assurance of a woman who knew she needed nothing to enhance her natural mien. Of course, she didn't. The woman was Irène Joliot-Curie, the daughter of Marie and Pierre Curie and the wife of Frédéric Joliot. She was a scientist in her own right and the recipient of the Nobel Prize with her husband.

Sandy clicked the shutter of his little Nikon just as Madame Joliot-Curie was about to give me her recipe for a tea cake. It was a simple picture of a simple woman sitting in front of a velvet curtain. A Parisian downpour outside ruined any hope of normal light, but the result looked like a planned studio setting.

We became good friends with Irène Joliot-Curie that afternoon, and, to our great surprise, she invited us to come to her house any or every Sunday to meet her husband, her family, and friends, play tennis, talk, and eat her cake, or listen to music. We went quite often to the Joliot-Curie house in Antony, a suburb of Paris. We found Frédéric Joliot-Curie a charming man and an excellent tennis player. Their friends were all notables in medicine and science, but they accepted us outlanders into their elite company.

One Sunday afternoon, Frédéric and Irène asked us all to take chairs into the living room because we were going to hear a great cellist play. I don't remember the cellist's name, but the poor man had trouble keeping his musical score from blowing away in the breeze from an open window. Frédéric sprang from his chair and motioned for all of us to be patient until he came back. When he returned, he solved the cellist's problem by placing a huge stone on the sheets of music, which anchored them perfectly until the concert was over. As soon as the last notes sounded, Frédéric rushed up to the improvised podium and grabbed the rock, apologizing as he dashed out of the room, "Excuse me, but I must return this to the laboratory. It's the only piece of pure uranium in Europe."

One of the heroines of my youth was Ruth St. Denis, an American dancer who followed in the footsteps of Isadora Duncan. Ruth St. Denis and her husband, Ted Shawn, had the dance company known as Denishawn. Martha Graham was part of this group, as were Doris Humphrey and Charles Weidman. The genre of dance the Denishawns choreographed and performed has now been replaced by the formal ballet techniques of Mikhail Baryshnikov and the outrageous but magnificent work of Twyla Tharp, but Ruth St. Denis made me realize that dancing did not require white tulle tutus and pink-ribboned satin ballet slippers.

One of the numbers on the Denishawn program was a suite, *Five American Dances.* The one that fascinated me was called *Gringo Tango,* performed by St. Denis and Shawn. I can remember buying the music and actually learning to play it. In fact, it is still one of the only things I can play after years of piano lessons.

My admiration of the Denishawn company in the thirties stayed hidden in my memory file until the day I realized that Ruth St. Denis was not only living in Hollywood but teaching as well. I found her in the telephone directory, called, and asked if my husband could possibly photograph her. She was delighted. But instead of the Ruth St. Denis of my youth, I met an elderly woman. She was rather stout and showed her eighty-five years, but she still had the grace and posture of a dancer. We talked for hours about her side of the footlights and mine in the audience. At one point I made a reference to *Gringo Tango,* telling her that I could still play it.

"Well," she said, "you go right over to that piano and play it, and I will dance it for you." And she did, almost exactly as I remembered.

Gino Severini was a master in the art of mosaics. He was also a great painter and part of the original cubist movement in France and Italy. I always wanted to visit Severini in his studio and learn to work with tessera, those small pieces of tile that, applied with an artist's eye and an artisan's technique, became masterpieces. Severini did his work wearing a forage cap made of folded newspapers, the insignia of a working stonemason. He was a charming man, and Sandy and I developed a close friendship with him. His two daughters, Gina (married to Nino Franchina) and Roma, became our friends as well.

I think Mr. Severini lived in the past. One day Sandy and I were having an aperitif with him at La Coupole when a gentleman approached and greeted Severini. Obviously, they hadn't seen each other in years. Severini introduced us to his friend: "Sandy and Beulah, please meet my old friend, Christian Dior, the architect."

Christian Dior, the architect? The year was 1950, and Dior was the most innovative couturier in Paris. His New Look had taken the world by storm. Gino Severini obviously did not keep up with fashion news and remembered Dior from the days when he actually was an architect.

Needless to say, we were thrilled to meet Dior and wished we had enough francs in our exchequer to afford at least a scarf designed by him. I suppose I, along with every other woman in Paris, New York, and London, had worn reasonable facsimiles of Rita Hayworth's historic blue Dior wedding dress.

Marie Laurencin was as lovely and delicate as her paintings. As she mixed the pinks and violets on her palette, she looked more like a housewife stirring a sauce than one of France's most eminent painters. Canvases covered her studio/apartment on Rue Vaneau. There were the vaguely shadowed ladies in bonbon pastels, the unicorns, and the mauve guitars immediately identifiable as Laurencins. She combined this dreamlike, elfin quality with a certain sophistication that made her work more than a child's fairyland. Laurencin paintings contained all the subtleties and secrets of the feminine mystique, all the knowledge that Woman has acquired since Eve.

Marie invited me to tea one afternoon and talked not of the past but of the present. "Some things I can tell you," she said. "I was born in 1885 and started to paint when I was seventeen. For me, the past is finished. Those days in Montmartre and Montparnasse are like the first act of a play. Now we are in the midst of a second, anticipating a third. Only the present is important.

"My life is quite orderly. Next to my work I think my greatest interest is in the Cat Club. I am at ease with the man on the street. I adore autobuses, zoos, the Seine, the bridges, and all the cats I meet. I have a horror of silverware and furniture. I prefer simple cupboards painted pink inside, filled with well-arranged things. I surround myself with musical instruments I cannot play and lots of books everywhere. Above all, I pity celebrities and never hope to be one!"

Monsieur Maeght, of the Galerie Maeght, was fascinated with Sandy's photographs and arranged for him to meet Chagall, Miró, Giacometti, and Dubuffet. We photographed all of them, but the most memorable was Joan Miró. The day we came to the gallery to see him, I was wearing a dress I had knitted. It was black embroidered with garlands of flowers in yarn. Miró was a charming and chivalrous man. A few minutes after our meeting, he admired my dress and asked me if I had knitted it myself. I told him I had and that working with yarn and needles quieted my nerves. I wasn't ready for his response.

"In that case, I will design a sweater for you to knit. It will be the offering of one artisan to another artisan." And he did.

A few days later we were with him at Mourlot's, where Miró produced his lithographs. He presented me with a pattern on graph paper for a sweater, with the advice to leave the background white and to do the border in violet and the triangles and rounded forms in primary colors. I immediately bought yarn in the prescribed colors and started the job. When it was finished a year later, it was a true and recognizable Miró, admired and envied by everyone. I intended to keep it forever, but one hot summer in Rome a battalion of hostile moths with no respect for artist or artisan munched through the vermilion triangles, the emerald green globes, the yellow lines, and—to finish their feast with a succulent dessert—the violet border. I said a sad good-bye to the sweater, hoping that Joan Miró, wherever he was, would never know about its fate.

Sandy and I had two props we used often. One was our cat, Louis, who intrigued everyone. The other was a slightly used Suit of Lights given to me by a bullfighter in Madrid. I don't think he was gored while wearing the outfit—there were no obvious signs of *that*—but there were signs of infrequent bathing and careless habits. He also gave me his *montero*, the marvelous hat that the bullfighter presents to an admirer. I kept the hat and the jacket; the trousers, I discreetly threw away. The jacket was extraordinarily beautiful. It was red satin with lots of gold, silver, and embroidery—a minor work of art. I re-

member showing it to Anna Magnani, who insisted on being photographed in it. Joanne Woodward saw it, and she, too, put it on. George Antheil, the composer, thought it suited him and wore it for a day and a half. Then Elizabeth Taylor fell in love with the idea of Sandy photographing her in the jacket and *montero*. It was an exciting photograph, and I think it made the cover of *Collier's*, a picture magazine of the era.

I rarely see Liz Taylor now, but she and Sandy and I were good friends for a long time. During the filming of *Giant,* two of my friends from Rome came to Hollywood. Rossana Podestà was an Italian film star, and her husband, Marco Vicario, was a director and actor. Sandy and I thought that it might be nice for them to meet Elizabeth Taylor and her then husband, Michael Wilding.

A dinner party seemed the perfect way for them to become acquainted. I planned an international menu—assorted Italian antipasto, roast beef, Yorkshire pudding, and apple pie à la mode for dessert. I did the cooking myself but hired Dudley, butler *extraordinaire,* to serve the drinks and the dinner. Dudley was the perfect gentleman's gentleman, the epitome of the British majordomo. He had worked in that role for Barbara Hutton and Cary Grant and occasionally valeted for my brother, Lenny. He lent status to any party, in his dinner jacket and black tie. In this case, he was better dressed than some of the guests. Rossana and Marco, being Italian, were dressed to the teeth. But when Liz and Michael arrived, I could see Dudley shudder. She wore blue jeans with no shoes; he wore white jeans and sandals.

The table looked beautiful with my Spode china and a few odds and ends of silver and Baccarat crystal that Dudley had brought along, probably from Barbara Hutton's collection. When Dudley announced, "Dinner is served, Madame," Elizabeth Taylor suggested that we eat on the floor instead of at the table. Dudley went into shock, and so did I. I knew Rossana and Marco had never heard of such a thing. Neither had I, except for a picnic on the grass. But eat on the floor we did, with Dudley stepping over our legs, passing the platters with great dignity, and pouring the wine without spilling a drop. There was a great deal of laughter and obvious enjoyment at this anti-establishment dinner, thanks to Liz Taylor.

The countryside around Verneuil in Normandy looked strangely familiar. A red earth road, a battered barn, a field of barley, and a stormy blue-gray sky streaked with large dramatic clouds. This was Maurice de Vlaminck's terrain, a landscape identifiable in most of his paintings. The farm dogs barked as we entered his courtyard, and, in the distance, carefully laid-out fields sown for food and sustenance. I had heard it said that Vlaminck was not rich like a *bourgeois* but rich like a peasant.

He looked like one. A powerful physique, a rugged, happy face, a worn tweed jacket, and a red *foulard* around his neck belied the fact that he was a painter with a worldwide reputation.

We drove to his cottage in Normandy quite often for lunch. At the table Vlaminck indulged in his favorite subjects—his colleagues. His

opinions of Picasso, the cubists, the dadaists, and the surrealists were unprintable. His manner softened when he spoke of his friends: Ambroise Vollard, his first dealer, poet Guillaume Apollinaire, writer Max Jacob, and painters Henri Matisse and Henri Rousseau.

In the dining room I noticed two small pencil drawings of Vlaminck and his wife Bertha. He took them off the wall and explained that they had been done by Amedeo Modigliani. His praise for Modigliani as the only true artist he had ever known brought on a few anecdotes about the man and the circumstances surrounding the two drawings. Vlaminck recalled that Modigliani was poor, that he never had a *sou*, but when he drank with friends at the Rotonde, he would pay for his share with small drawings done on paper napkins. He used these as if they were banknotes. Vlaminck also remembered a cold winter day in 1917 when he saw Modigliani in a doorway on Boulevard Raspail. Modigliani stood there with a certain pride and haughtiness, regarding the passersby as if he were a general inspecting his troops. When he saw Vlaminck, he nonchalantly approached him and said, "I am selling you my overcoat. It is too big for me. It will look good on you!"

After telling us this story, Vlaminck was silent for a moment. Then he said, "In these days when the words *art* and *artist* are used so loosely, they lose their true sense. We speak of an artistic hairdresser, a culinary artist. The word *artist* is so misused, I hesitate to put it into a sentence, but in Modigliani's case, I will. *He was an* artist!"

Vlaminck gave me one of his unpublished books, which I offered to translate into English. Only recently, in looking at the manuscript, did I realize that he had inscribed it to "Darling Roth." I imagine he assumed that "darling" was my first name because he never heard Sandy call me anything else.

The very thought of telephoning Henri Matisse for an appointment kept me up all night, but it had to be done and I had to do it. I had heard from his colleagues that he was irritable about intrusions into his privacy. He was aging and ill, and his reputation for intolerance was becoming more acute as he grew older. I made the call to Monsieur Matisse in Nice from a small village, Les Saintes-Maries de la Mer, in the Camargue. The Camargue, on the Golfe du Lion in Provence, is a salty swamp in the winter, a salt supplier for France in the dry seasons of spring and summer. We were there to photograph the annual gypsy conclave honoring their patron saint, Sarah. Gypsies from all over Europe arrived for this festival. They came in expensive motor homes, old-fashioned gypsy wagons, ancient trucks, on foot, or by whatever means they could find, from the Soviet Union, Spain, Hungary, Ireland, England, and elsewhere. The little town of Les Saintes-Maries de la Mer became a minor metropolis teeming with swarthy men, sexy women, swirling skirts, cooking fires, music, and flamenco dancing. The noise was tumultuous and continuous. My telephone call to Matisse from a café was barely audible to him or to me.

One nice thing about famous people in France is that they answer their own phones. There was no "He's at a meeting at the moment.

He'll call you back" or "Let me put you on hold, he is on another line." No, Matisse's phone rang only once, and when I asked for Matisse he said I was talking to him. "What is that noise?" he asked.

"Gypsies," I said. "Can we come to photograph you?"

"Yes, if you stay five minutes. Come tomorrow afternoon." The tone of his voice was a command. We were more than four hundred miles from Nice, at least eight hours' travel time, but we arrived at Matisse's apartment at about two o'clock the next afternoon. He was not very cordial. "You have interrupted my afternoon sleep," he grumbled, "so just get on with what you have to do."

As I look back to the visit, I think that Matisse expected to see a barrage of cameras and lights and a staff of assistants. Instead Sandy had only that unobtrusive Nikon and a wife who was absolutely fascinated by the room we were in, to say nothing of the presence of Henri Matisse himself. The room was in his apartment at the Hotel Regina, named after Queen Victoria, who spent a few months there every year. It could have been anyone's room in any apartment, but this was where Matisse worked. At the window was a lacy wooden screen he used in all of his *odalisques*. The light filtered through as it did in his paintings. The walls were decorated with groups of his colored paper cutouts—leaves, abstracts, dance forms, all familiar to me from books and catalogues.

While Sandy photographed him, Matisse went through his mail, deliberately opening each envelope slowly. He cleaned his eyeglasses constantly and tried to appear detached and unaware of the camera. Then, suddenly, he looked at his watch, an obvious hint that we were to leave. We said good-bye and thanked him for his time and patience. He grunted a reply, and we left, our mission more than accomplished.

Actor Edward G. Robinson was the consummate man for all seasons. His knowledge of art was so profound that we often thought he would have made an excellent art historian or curator. His collection included a large Monet (one of the water lilies series), a Bonnard, a Vuillard, a Cézanne, a Soutine, and many others. Our own art collection seemed meager by comparison. We had a signed Braque lithograph, a signed Picasso lithograph, three or four Mirós, some good drawings, and a few contemporary Italian paintings, none of them museum quality and certainly not in Edward G. Robinson's league.

I did have one painting that interested him. It looked like an early Vuillard in both subject matter and composition, but as often as I tried to have the painting authenticated in New York, Paris, and Rome, the answer was always "It might be or it might not be." Edward G. Robinson always believed that it was a Vuillard and never missed an opportunity to ask me, "How is your beautiful Vuillard?" But when I asked him what he thought of the rest of our collection, he said, "Fine, excellent, perfect—for a beach house."

He always knew what he was talking about when the subject was art—or politics, or wine, or food, or authentic Chippendale chairs, or recipes. I don't think he ever cooked, but he loved to hear about recipes from great chefs. Sandy photographed him talking to one of

the most famous chefs in the world, Henri Charpentier, who gave up cooking for the crowned heads of Europe to open his own very small restaurant in Newport Beach, California. Charpentier is known as the man who invented crêpes Suzette. Whether they were discussing crêpes, wine, lobster thermidor, or the best way to roast a duck, I will never know.

Rock Hudson was a good friend. We loved him. Sandy worked with him on many films, but to get good magazine photographs Sandy had to go wherever Rock went—once it was to buy a piano. The photograph in this book represents the Rock Hudson I knew then. He was very tall, very handsome, and a darling man, as the Irish would say.

One day when Rock came to our house, I was knitting a sweater for Sandy. Actually, I was copying a sweater he had bought in Italy. Rock loved the original one, so Sandy told him to take it as a present. But when Rock tried to put it on his six-foot-plus frame, it was too small. Disappointed, he came up with an idea. "Why don't you teach me how to knit, so I can make one for myself?"

I agreed to teach him the fundamentals: holding the needles properly and pulling the yarn over the back for knit, over the front for purl. He was awkward at first, but who isn't? I assured Rock that men all over the world found knitting and needlepoint a great source of relaxation. Rock left with a pair of needles, a ball of yarn, and some written instructions. I don't know whether he got any further than that; I always forgot to ask.

Chuck Walters, who was Joan Crawford's director and a choreographer at Metro-Goldwyn-Mayer, asked us to come to his house in Malibu for lunch. Joan would be there rehearsing for her new film, *Torch Song*. Sandy had already photographed her in her dressing room, and the result—Joan applying makeup and her image in a mirror—had become famous.

We entered Chuck Walter's magnificent house and found Joan already there, in black net tights and leotard. Her figure was perfect—as far as I was concerned, everything about her was perfect. Despite the stories about her standoffishness, she was charming and friendly. At one point she remembered that she knew my brother quite well. "Do you mind if I tell you a funny story about him?" she asked.

There were many amusing stories about my brother, but one coming from Joan Crawford I really wanted to hear.

"Well," she began, "it was during the time I was married to Franchot Tone, and elegant formal dinner parties were the thing to do. I planned a party, as we did in Hollywood in those days, with an even number of men and women—not for mating, just to make the table look good. At the last minute a male guest couldn't come, and that's where your brother came in. Lenny was an invaluable asset to any party. Not only was he witty, he was an unattached extra man. He had come from New York only recently and was the epitome of

sophistication. Or so I thought.

"When dinner was announced, we all found our places at the table. Lenny was at my left. There was an artichoke on each plate with a dish of melted butter beside it. I saw Lenny stare at the vegetable with curiosity, and I knew instantly that he didn't know how one ate this exotic thing, or even what it was. I caught his eye and delicately peeled off an artichoke leaf, dipped it in the sauce, and silently urged him to do what I was doing. He got the idea immediately and even followed my subtle directions on how to get to the heart. Later in the evening, he came to me and thanked me for the lesson.

" 'Do you mean,' I asked him, 'that you never saw or ate an artichoke before?'

" 'No,' he confessed, 'I think I saw one once in the Brooklyn Botanic Garden. Believe me, Joan, I thought your first course was cactus!' "

Her instructions on how to eat an artichoke made my brother an ardent fan not only of artichokes but of Joan Crawford as well.

I used to be obsessed with the crazy idea that I looked like Audrey Hepburn, even though there was no resemblance whatsoever in bone structure, ethnic background, or, above all, weight. I prayed for those bony shoulders, that swanlike neck, and the ability to wear Hubert Givenchy's gowns without a hip distorting the straight up-and-down structure of his designs.

One day in Paris, I read that Givenchy was having a sale. Sales are my passion anyway, but I had a special purpose in going to this one. I entered the Givenchy salon and disdained the boutique items. My goal was the upper floor where the haute couture gowns had been reduced for clearance. The moment of truth had come at last. There were a few Hepburn-like ball gowns left. It was now or never. Did I have the courage to rid myself once and for all of the fantasy that I could wear the gowns of my dreams? A *vendeuse* in a little black dress and pearls brought me a yellow satin, an emerald green moiré, and a red chiffon. My *belle poitrine* broke the zipper in number one, my hip bones split the seams of number two, and the price of number three was too high to warrant trying it on—and probably ruining it for someone who might actually be a clone of Audrey Hepburn.

My husband had worked with Audrey Hepburn on *The Nun's Story* in the Belgian Congo (now Zaire). He adored her, too, and the combination of Sandy's photography and Audrey's cooperation had earned a cover of *Life*. When the film company left the Congo and came to Rome to finish shooting, Audrey stayed at the Hassler Hotel with her dear little Yorkshire terrier. Sandy said to me, "I am taking you to meet her tomorrow afternoon, so you can see for yourself that any resemblance between Audrey and you is purely psychotic!"

I felt she deserved some kind of offering—a small gift, something inexpensive but interesting. In Florence a few weeks before, I had bought two strawberry vines made of raffia to be used as a belt or around a straw hat. I decided to give one of them to Audrey. Then, in a confectioner's window, I saw little strawberry baskets filled with marshmallow berries colored red with crystallized sugar. They

looked so like real strawberries they had fooled me at first. I had a little basket wrapped and beribboned to give Audrey as an homage. She was enchanted with the idea of wearing the raffia strawberry vines around her waist (all twenty-one inches of it). Then I presented her with the box of *faux* strawberries. They were meant to be an amusement, to fool the eye, and they certainly fooled Audrey Hepburn. She confessed in no uncertain terms, "I hate strawberries." Being Audrey Hepburn, however, she quickly added, "But I love your suit and blouse. Where did you get them?"

One day in the spring of 1955, Sandy called me from Warner Brothers in Hollywood to ask if he could bring a young actor home to dinner. "What are you having?" Sandy inquired.

"Curried chicken. Do you think your new friend will like it?"

Sandy's new friend was James Dean. Jimmy had just returned from Marfa, Texas, where he had been working on *Giant,* and Warner Brothers had called Sandy back from Rome to photograph him. Jimmy's palate was more attuned to chili and hamburgers, pizza and tacos than to curried chicken, but he loved the chutney. He said it tasted like the plum preserves his aunt had made on the farm back in Indiana. He helped wash the dishes that night and, through some mysterious chemistry, the farm boy and the two Brooklynites became fast friends until the day he died.

Our backgrounds couldn't have been more different. Jimmy knew how to milk a cow. We didn't. Jimmy knew how to change spark-plugs. We didn't. Jimmy could hum Béla Bartók. We couldn't. Jimmy could build a shelf. We couldn't. On the other hand, we could quote from Oscar Wilde. He couldn't. We had seen a bullfight in Spain and hated it. He had never seen a bullfight but hoped not only to see one but also to participate as a matador. He was young and we were not, yet our relationship was *not* that of surrogate parents or doting aunt and uncle, as has been suggested. The friendship started and stayed on an equal footing; chronological ages were never considered. There may have been a gap between Jimmy's generation and ours, but it was bridged by the unconventional lives we all lived. We must have seemed quite different from the other adults he had met, perhaps a bit more adventuresome. He showed up at our house often—sometimes invited, sometimes not, but always welcome.

Jimmy *liked* us, but he *loved* our cat, Louis. We soon realized that he was really Louis's guest, not ours, and Louis was a generous host. He let Jimmy sit on his "throne," an eighteenth-century Venetian chair. That's where Jimmy always fell asleep with Louis on his lap. The two of them dreamed together. Jimmy may have dreamed of Indiana and the shadow of a mother who was taken from him early in life, or of the trip to Paris he planned to take with us.

The Paris visit was to take place in November or December of 1955. I had a large map of the city and its subway system. We would spread the map on the floor, and Jimmy, Sandy, and I would take imaginary walks down Boulevard Montparnasse and then down Boulevard Raspail. We showed Jimmy where Picasso worked, and introduced him to the cafés, La Coupole and Les Deux Magots. We promised him a gala dinner at Le Doyen and a not so gala one at our neighborhood bistro, La Corbeille.

"Can you really go to the top of Nôtre Dame?" he asked.

We assured him that we had.

"Can you go to the highest point of the Eiffel Tower and see all of Paris?"

"Yes, Jimmy, you will see everything and meet everyone, including Picasso."

Jimmy grinned and said, "I guess I'd better study some French and learn about Existentialism!"

He never went, of course, but we did. For a long time, we put a third chair at our café table for Jimmy.

So many years have passed since that dark September day in 1955 when Jimmy was killed.

The legend of James Dean started, I believe, because people did not want to accept the death of a hero. There are James Dean cultists all over the world. I have talked with hundreds of people who idolize his screen persona—people as diverse as a sixteen-year-old high school student in Nebraska and a middle-aged Japanese industrialist in Tokyo, Parisians, Londoners, Moscovites, Madrilenians, and Romans. These people never met James Dean, the man, but they seem to find a part of themselves in his screen image of the misunderstood youth and in his symbols—blue jeans, leather jacket, and striped knit shirts, which were my husband's, given to Jimmy because he loved them.

I am sure Jimmy is watching all of this hullabaloo from wherever he is, his myopic eyes gazing through his glasses, and he's chuckling in his inimitable way.

Sandy was a special and multi-talented man, but he was lucky, wise, and courageous enough to make a career of the thing that he loved most. For those interested in the technical aspects of his work, he generally used thirty-five-millimeter cameras. He started with a Leica, then had a Contax, and finally settled on a Nikon. He had five of them, and they were always loaded and ready to use. His camera was always hand-held; he did not own a tripod, flash, or strobe. He relied completely on natural or available light. His chemical formulas for developing and printing were commercial types, with slight variations of his own invention. He used medium-speed panchromatic film, always black and white unless a specific order from a magazine demanded color. His photographs appeared in *Life, Look, Paris Match, Elle, People, Harper's Bazaar,* and *Oggi.*

Sandy died in Rome at the Inghilterra Hotel on Via Bocca di Leone on March 5, 1962.

Beulah Roth

The Portraits

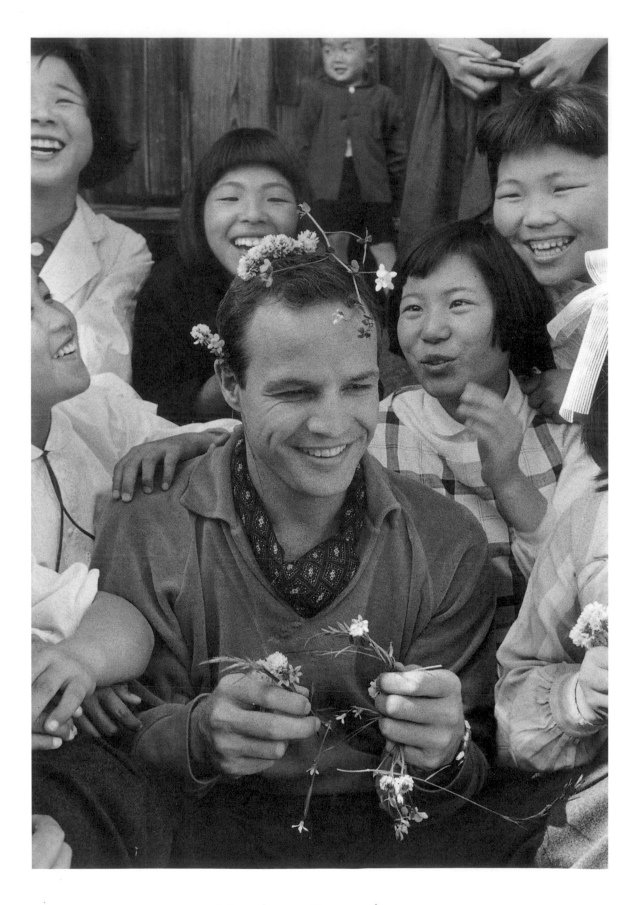

Marlon Brando

TOKYO

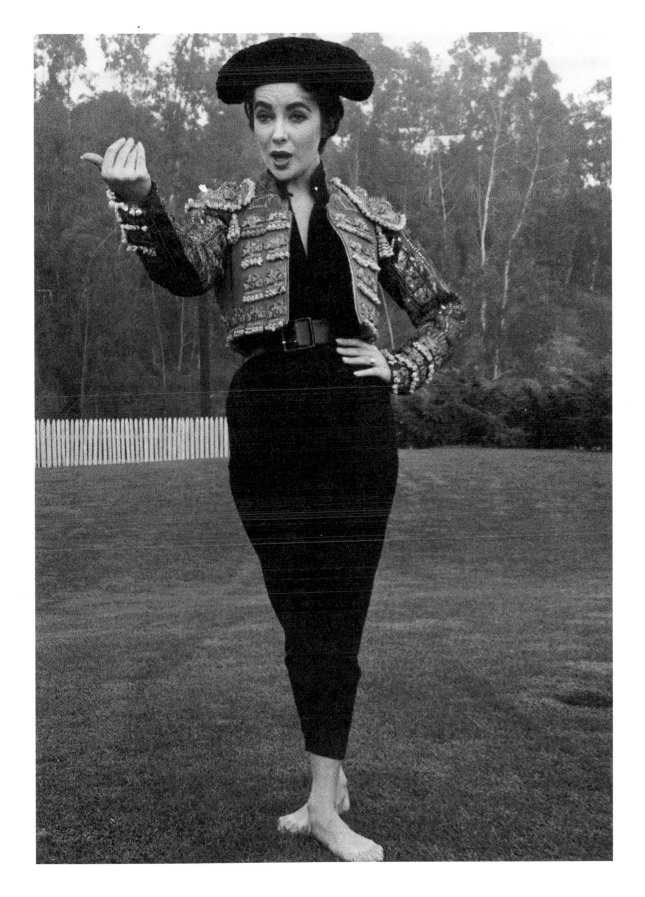

Elizabeth Taylor

LOS ANGELES

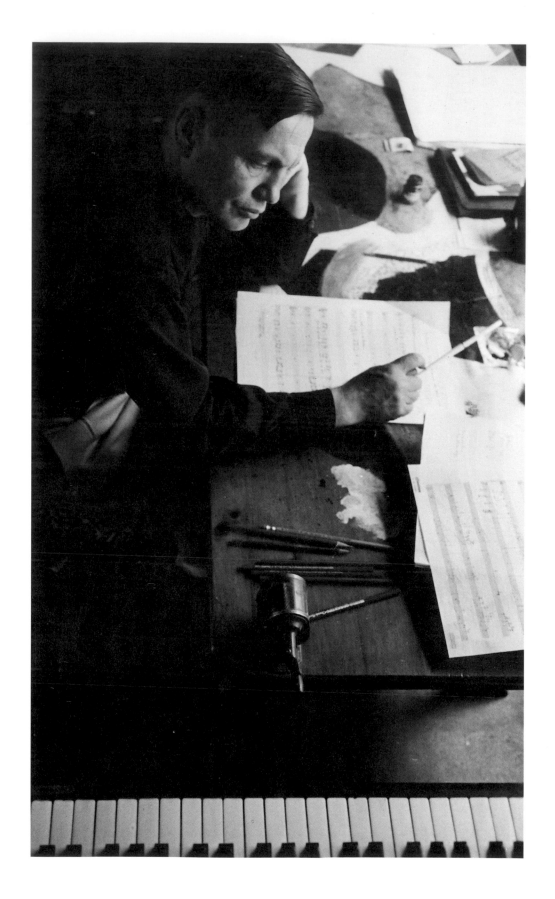

George Antheil

LOS ANGELES

Igor Stravinsky

LOS ANGELES

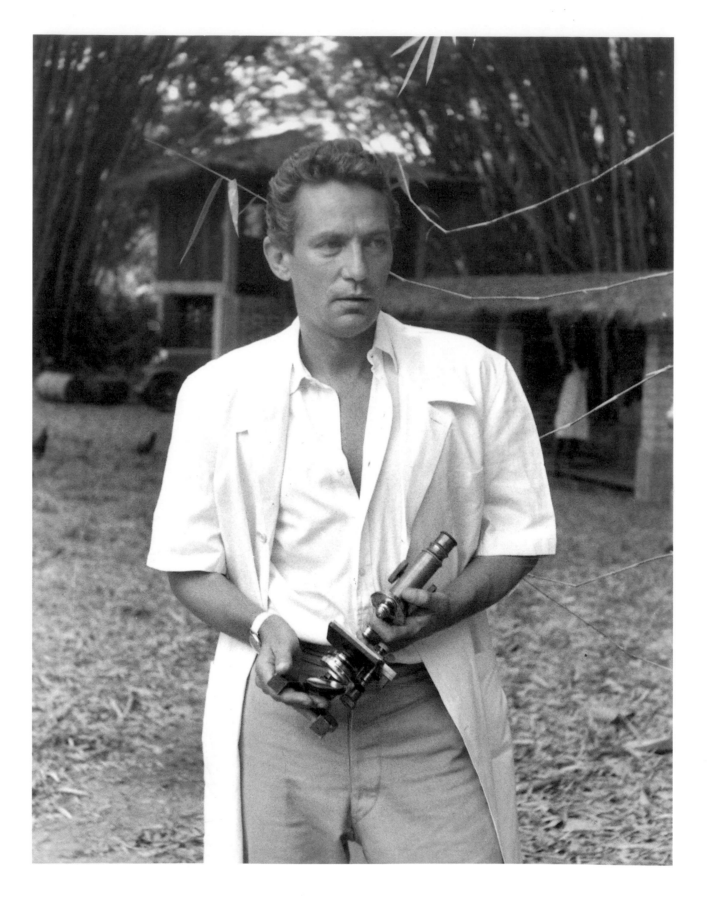

Peter Finch

BELGIAN CONGO (ZAIRE)

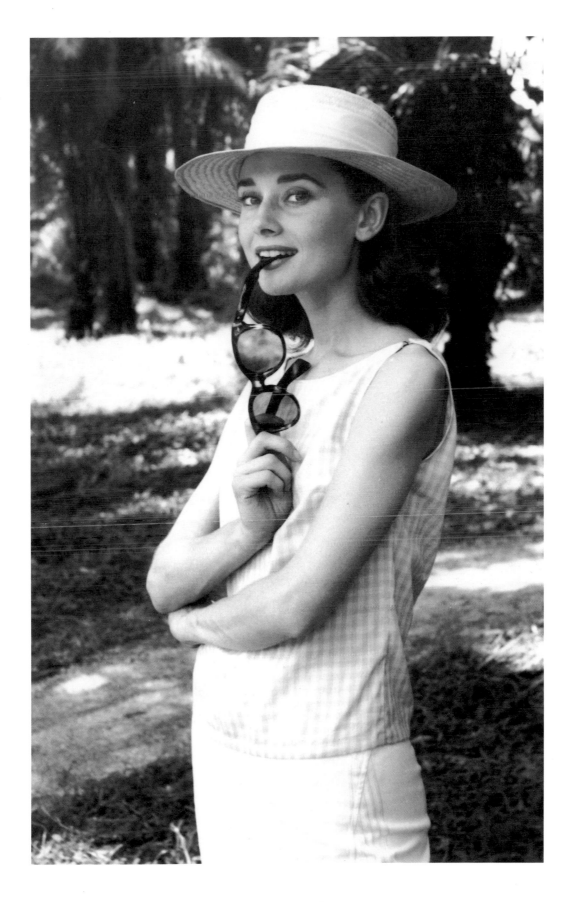

Audrey Hepburn

BELGIAN CONGO (ZAIRE)

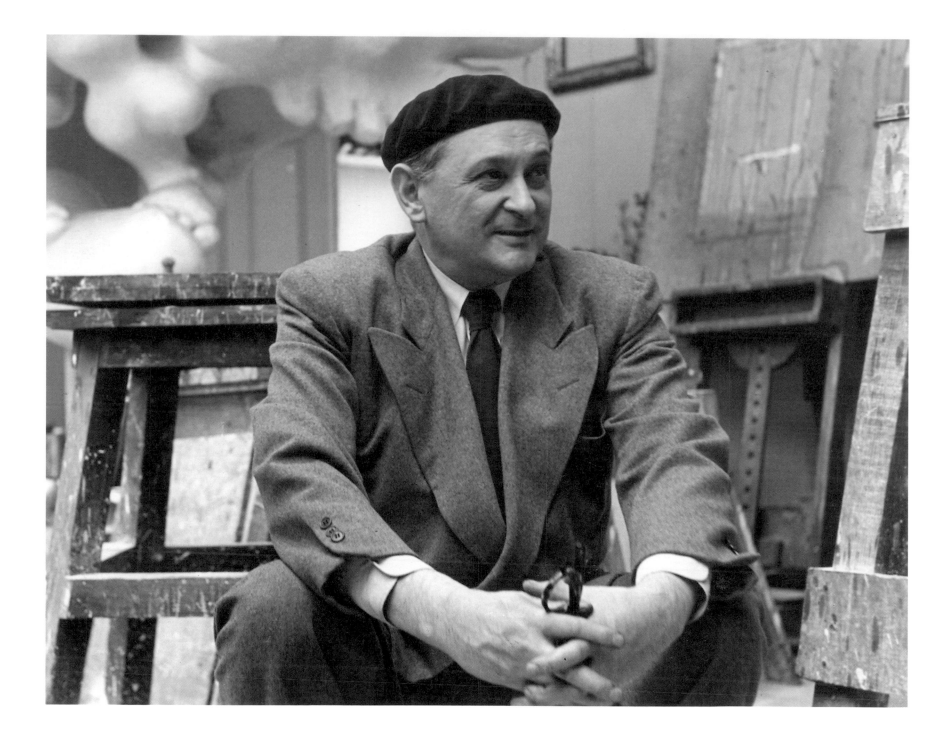

Jacques Lipchitz

NEW YORK

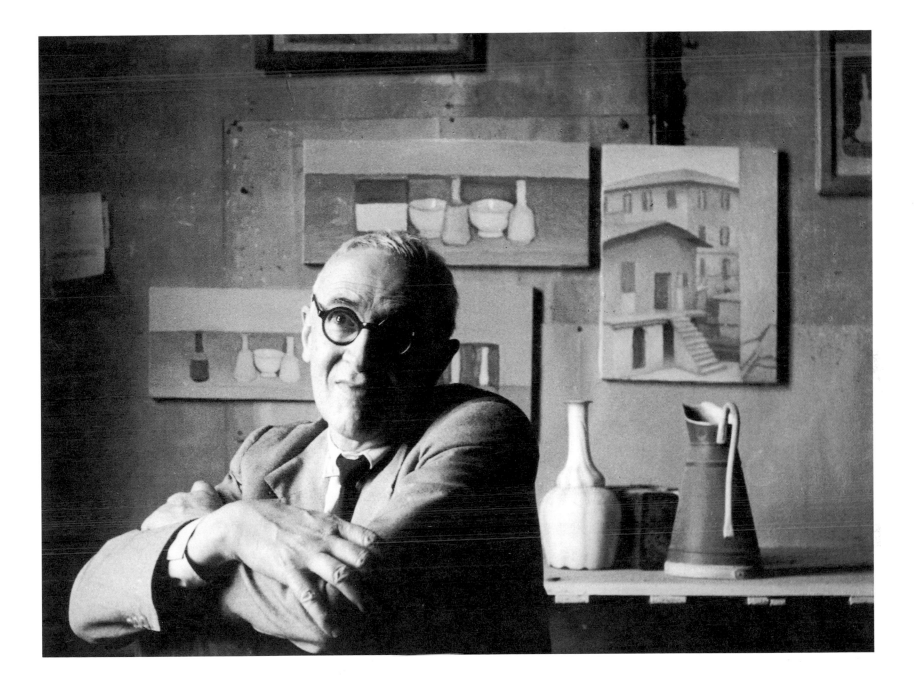

Giorgio Morandi

BOLOGNA

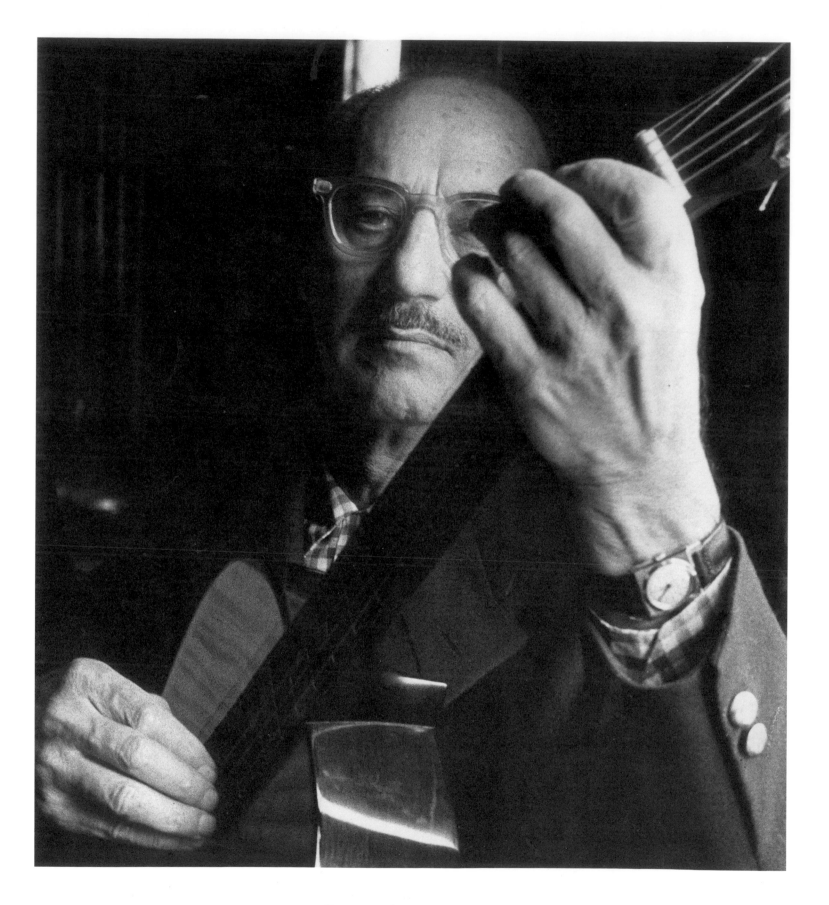

Groucho Marx

HOLLYWOOD

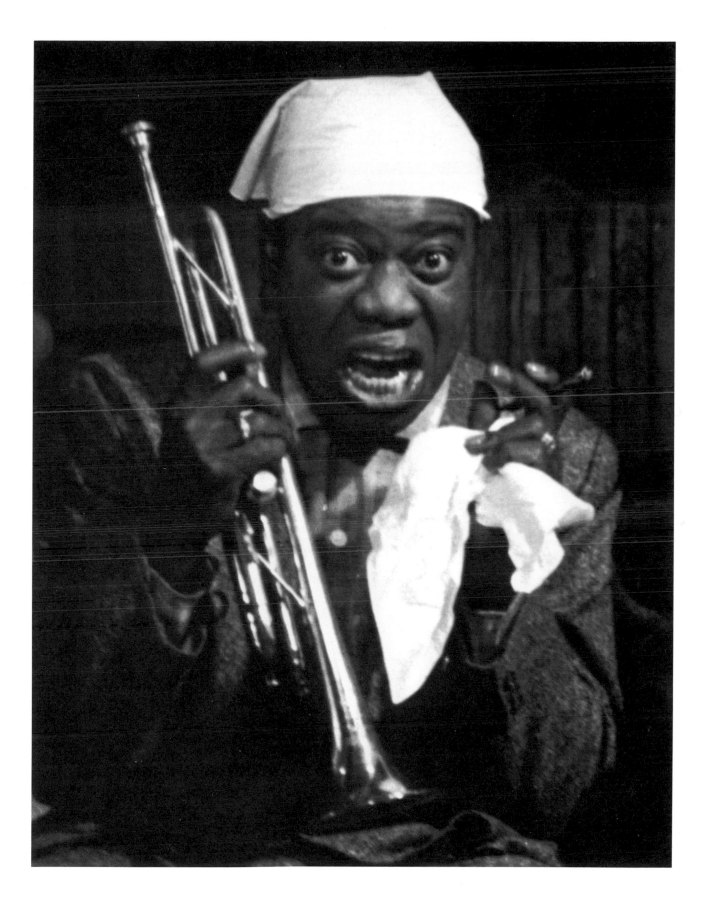

Louis Armstrong

HOLLYWOOD

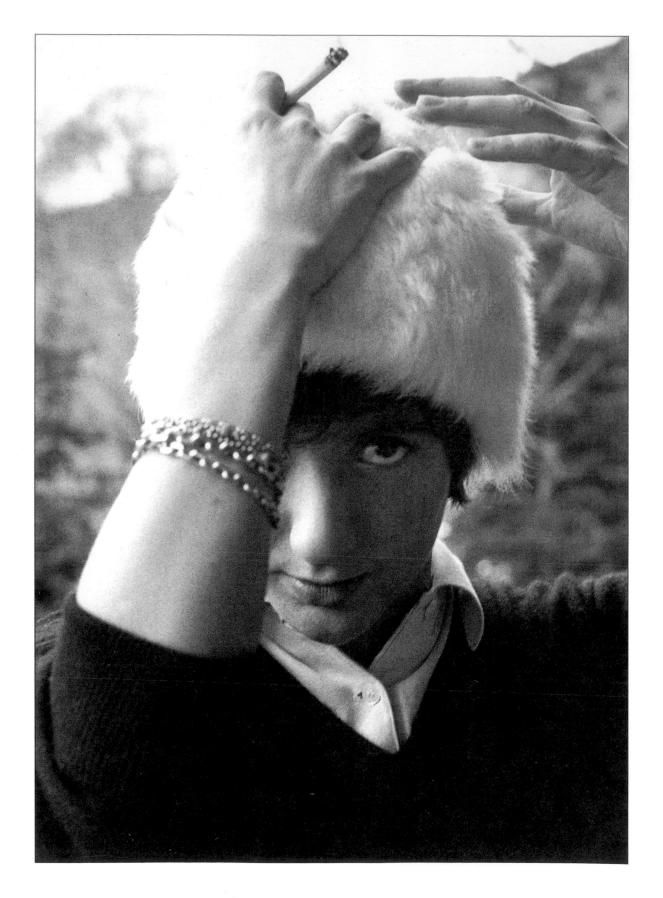

Françoise Sagan

KLOSTERS, SWITZERLAND

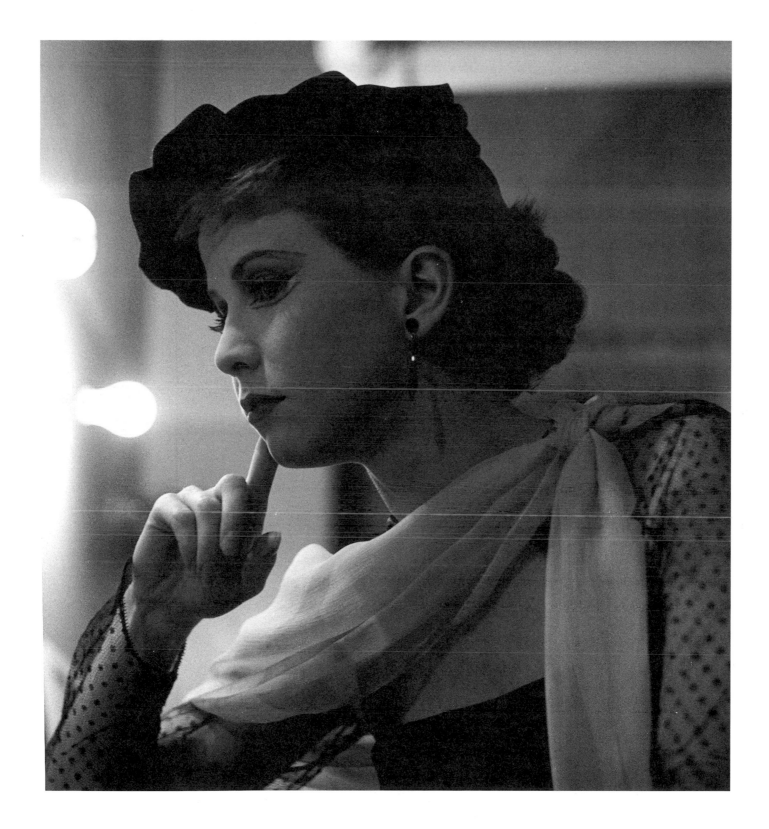

Julie Harris

LOS ANGELES

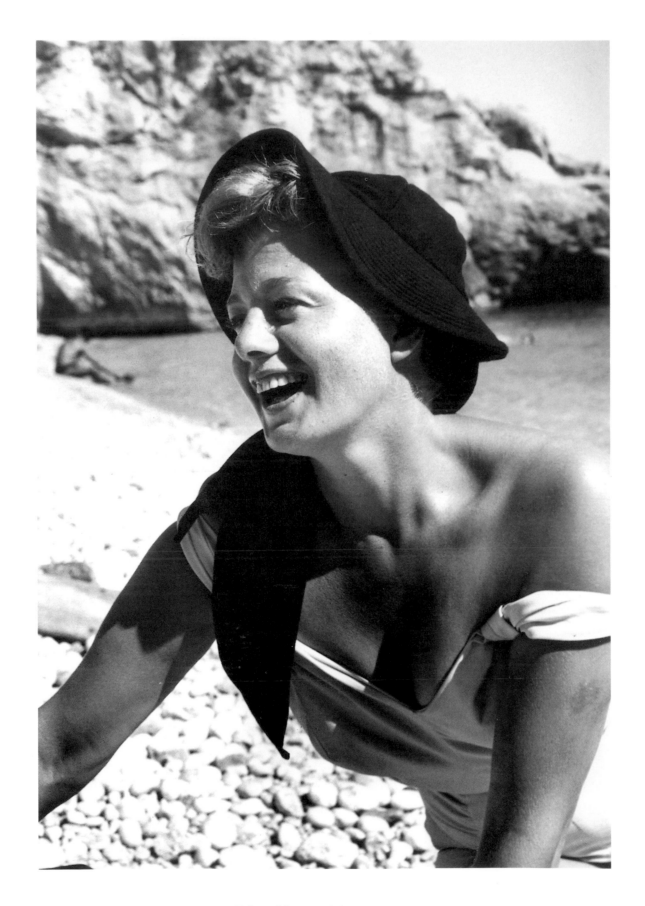

Shelley Winters

CAPRI

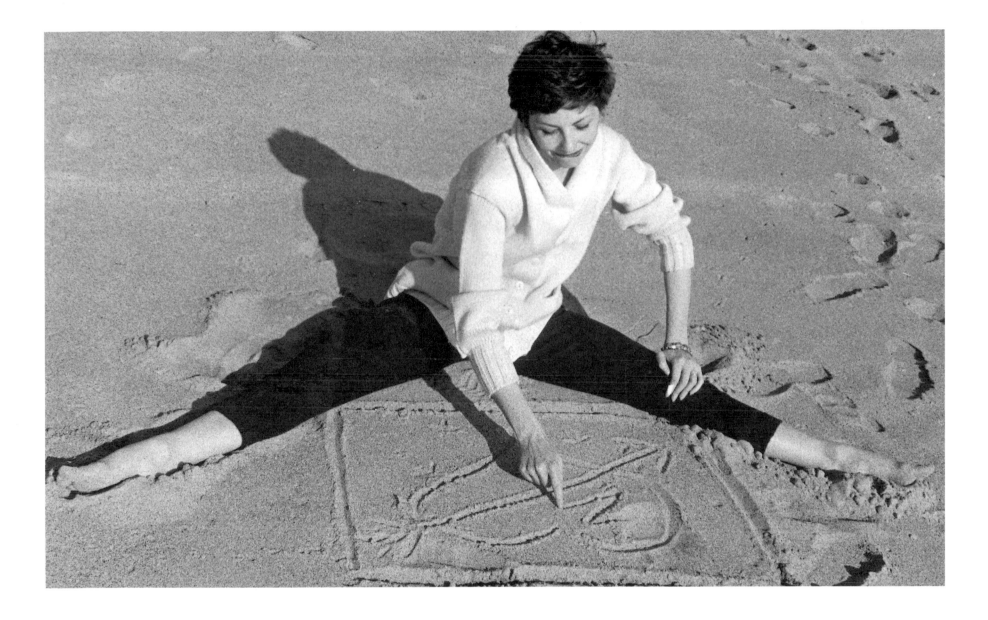

Zizi Jeanmaire

MALIBU

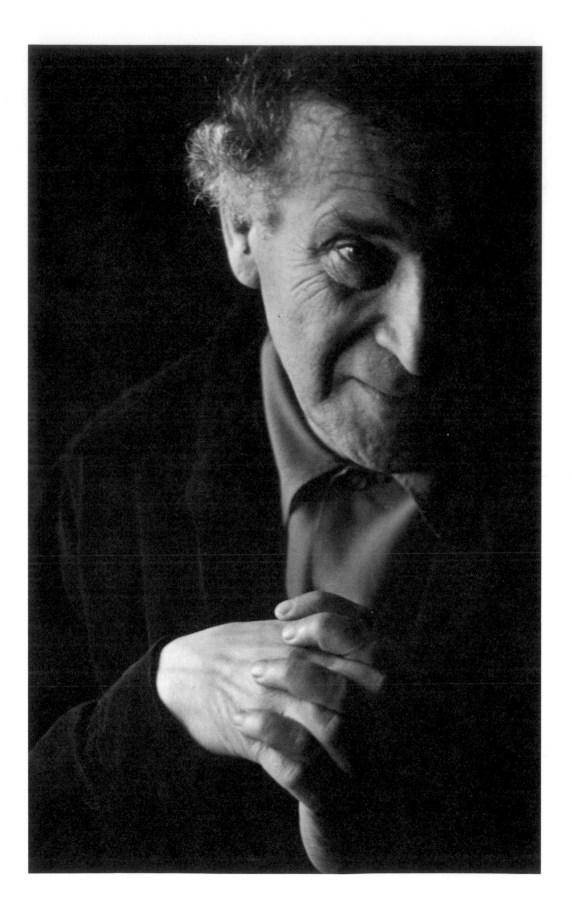

Marc Chagall

PARIS

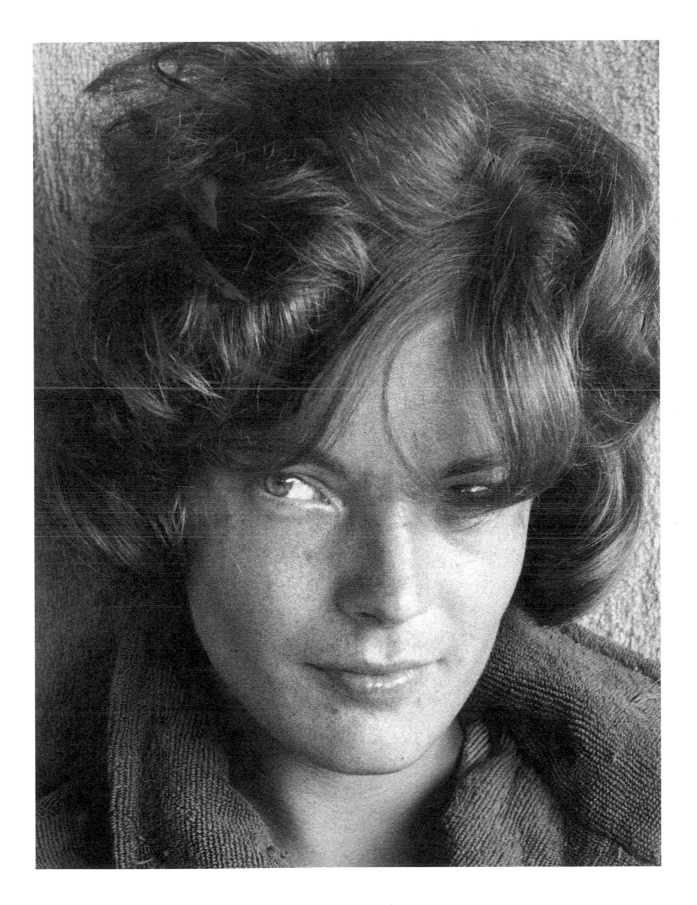

Romy Schneider

ROME

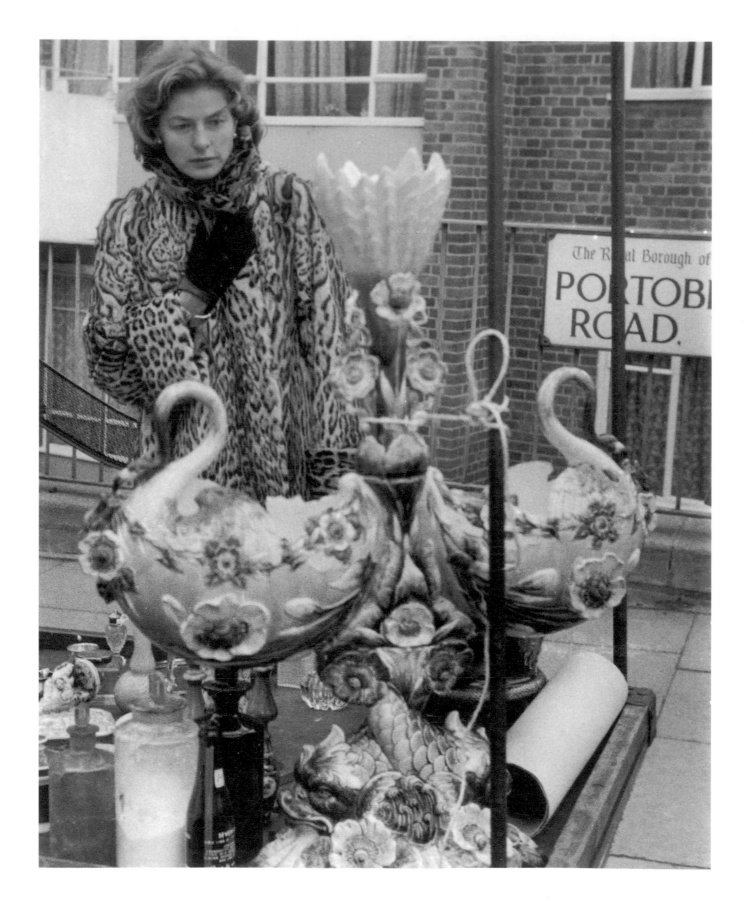

Ingrid Bergman

LONDON

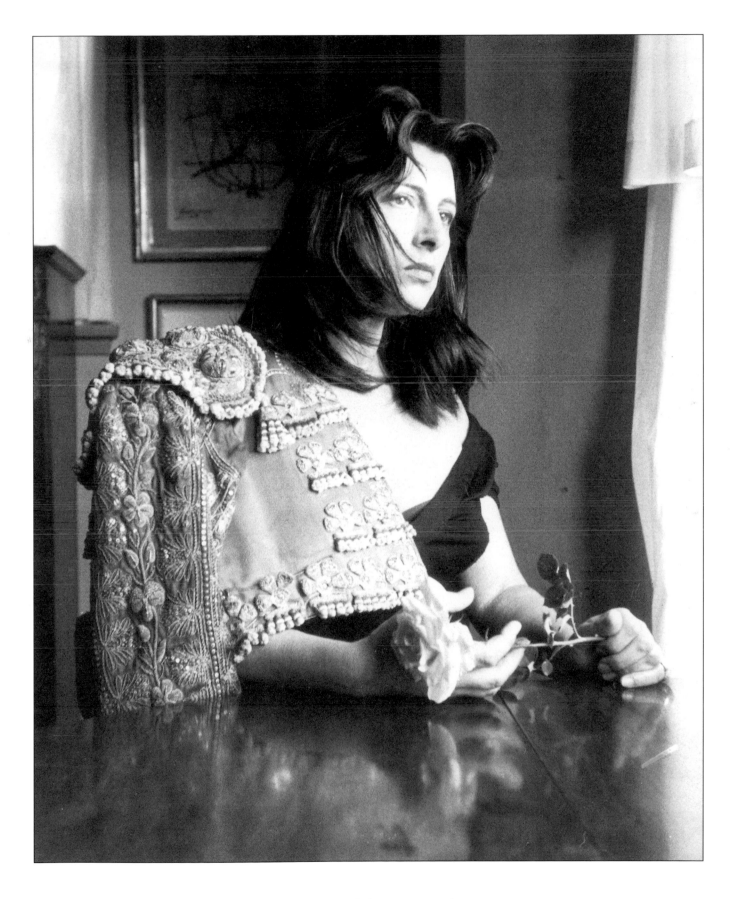

Anna Magnani

LOS ANGELES

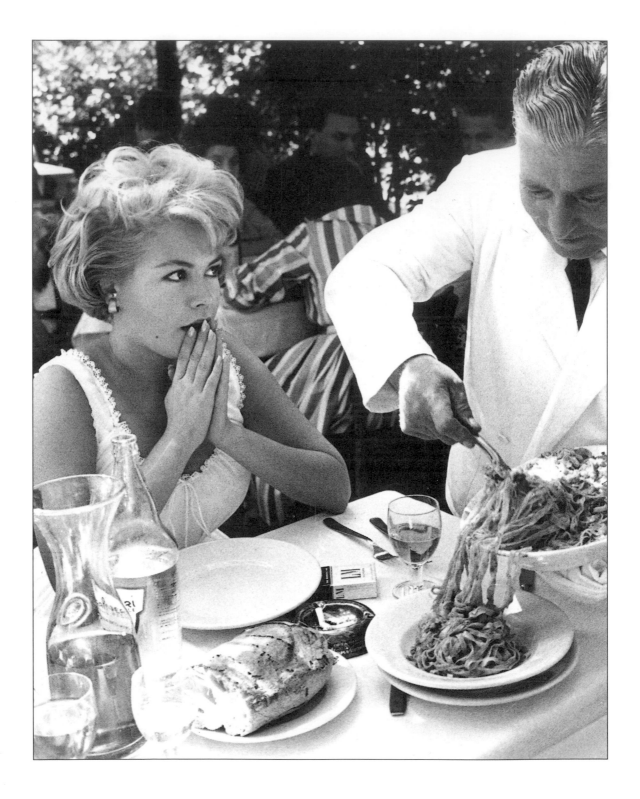

Sandra Dee

TODI, ITALY

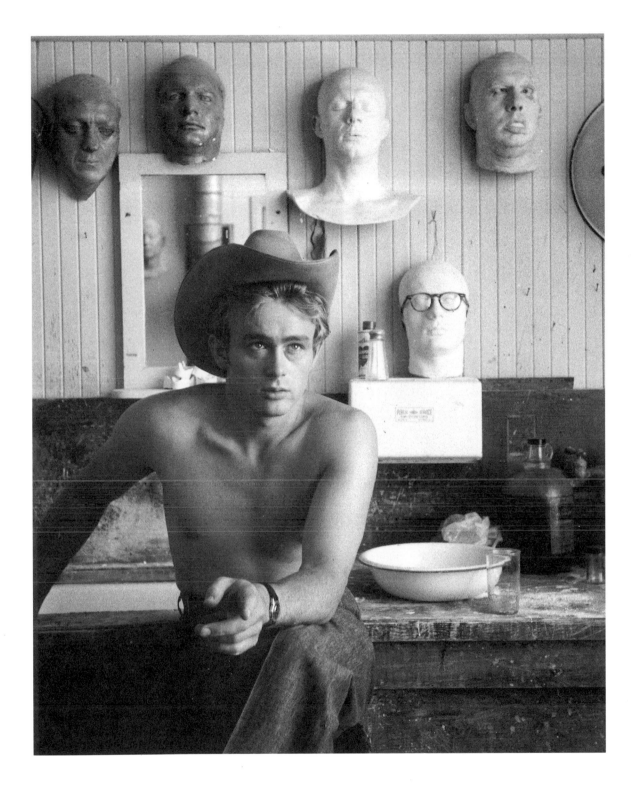

James Dean

HOLLYWOOD

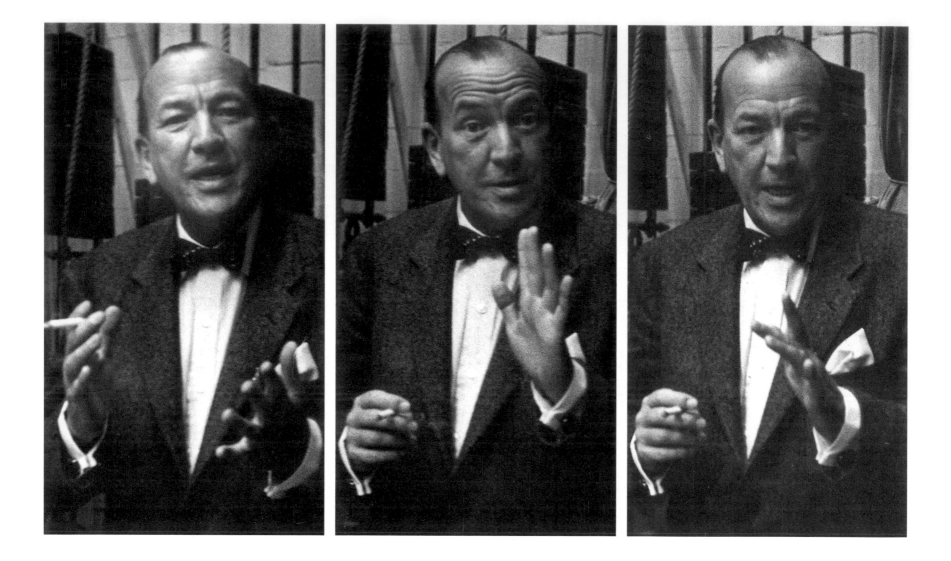

Noel Coward

LOS ANGELES

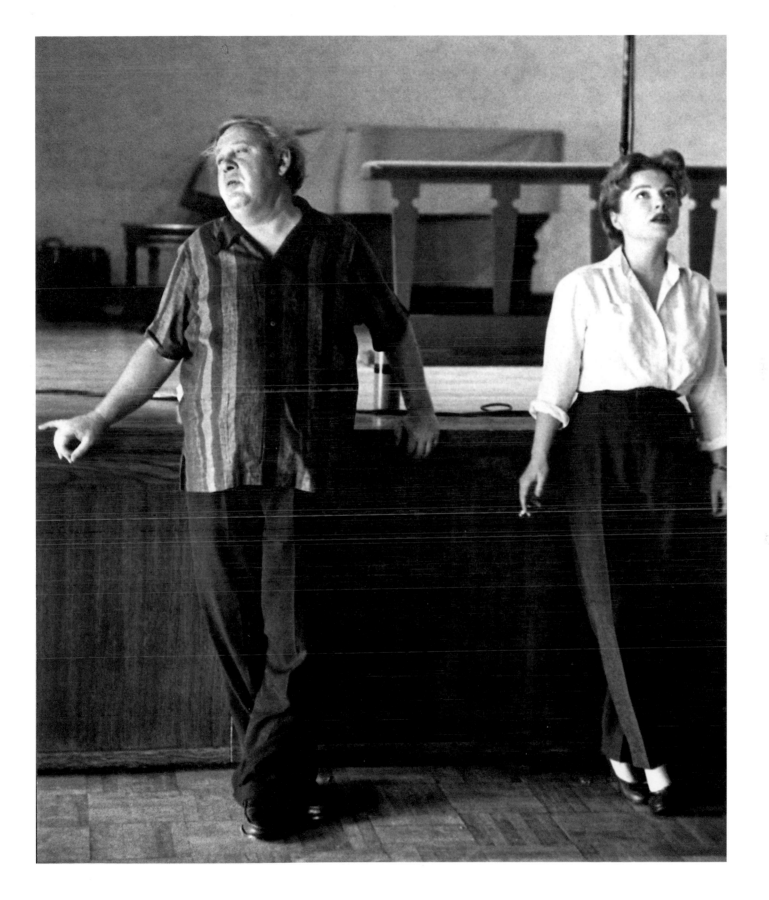

Charles Laughton and Anne Baxter

HOLLYWOOD

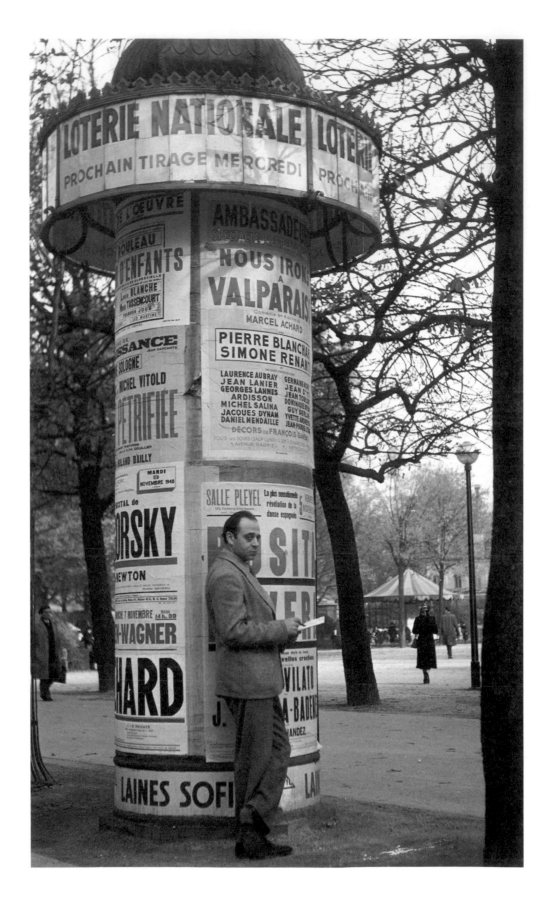

Arbit Blatas

PARIS

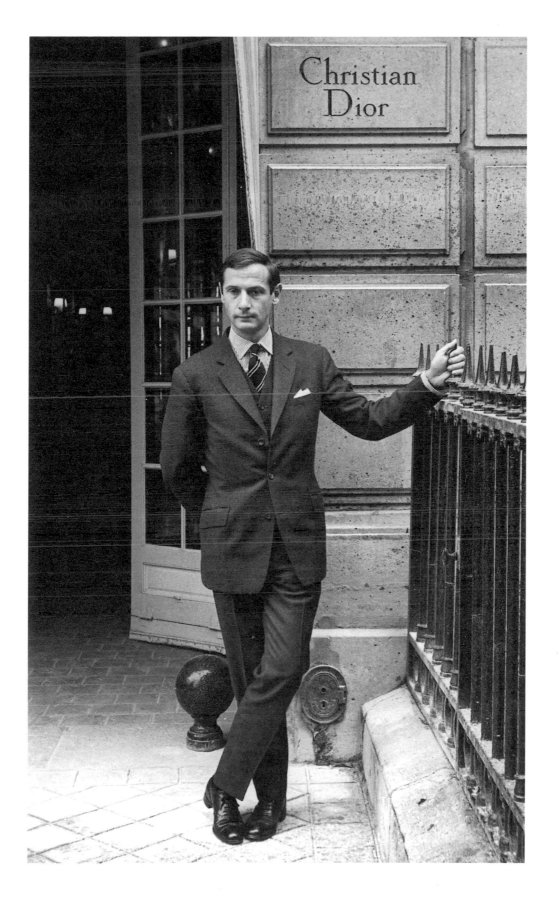

Marc Bohan

PARIS

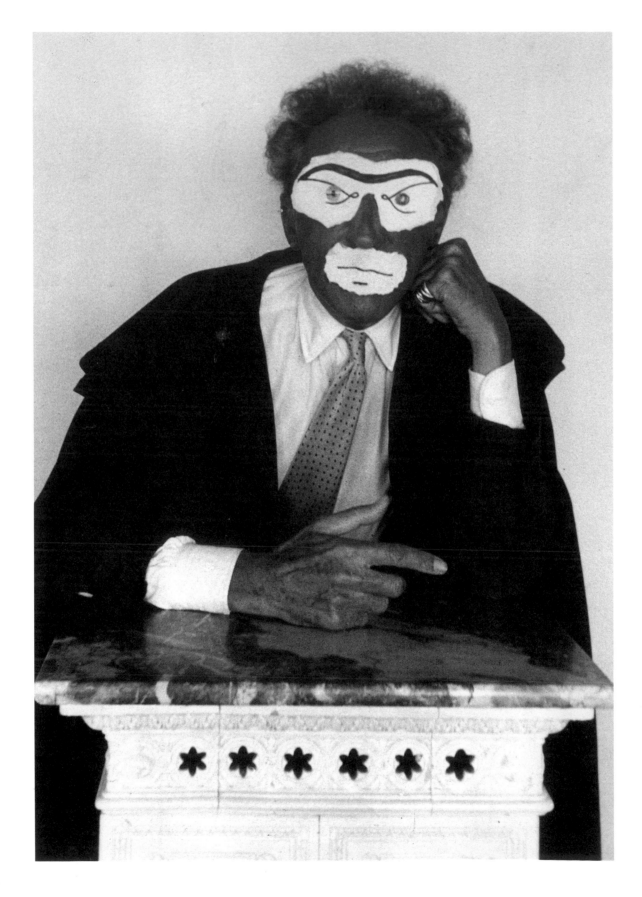

Jean Cocteau

PARIS

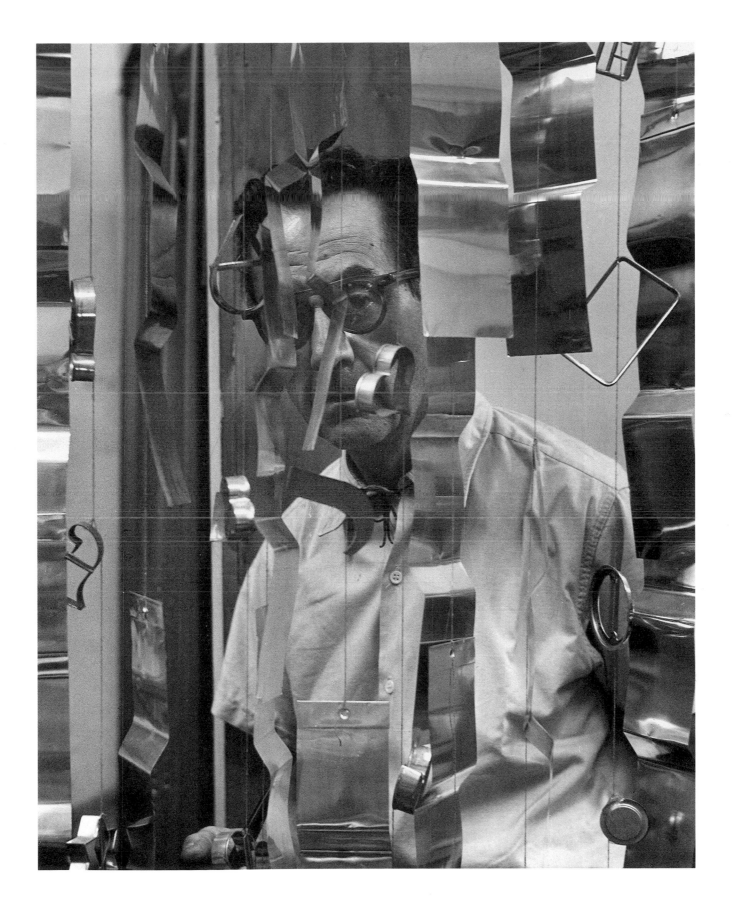

Man Ray

PARIS

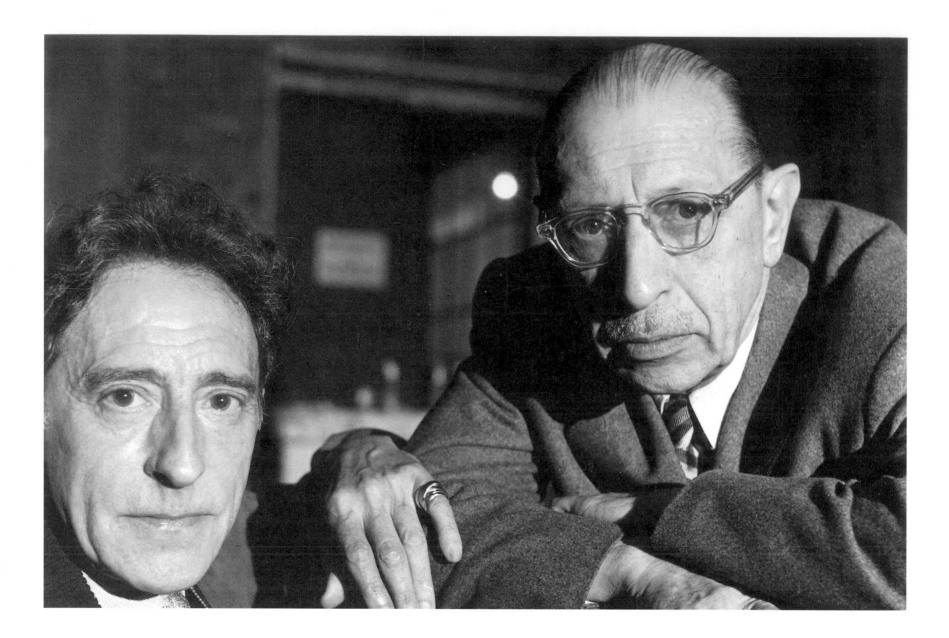

Jean Cocteau and Igor Stravinsky

PARIS

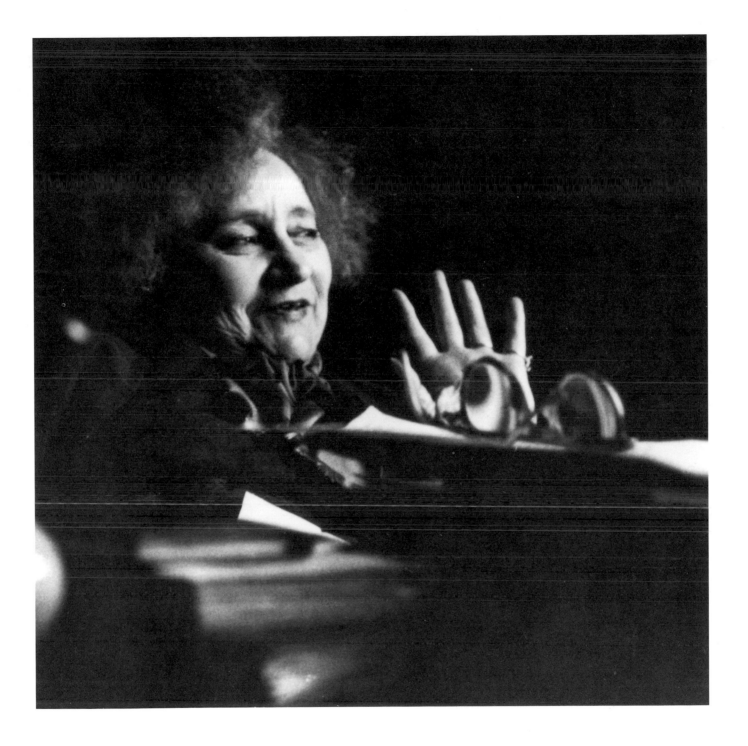

Colette

PARIS

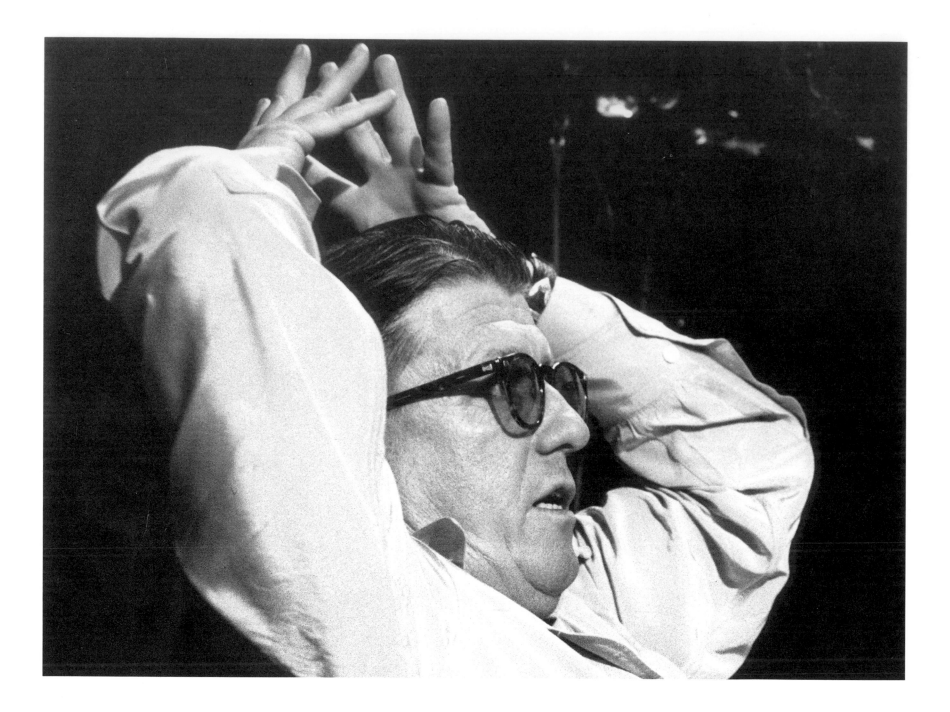

George Stevens

HOLLYWOOD

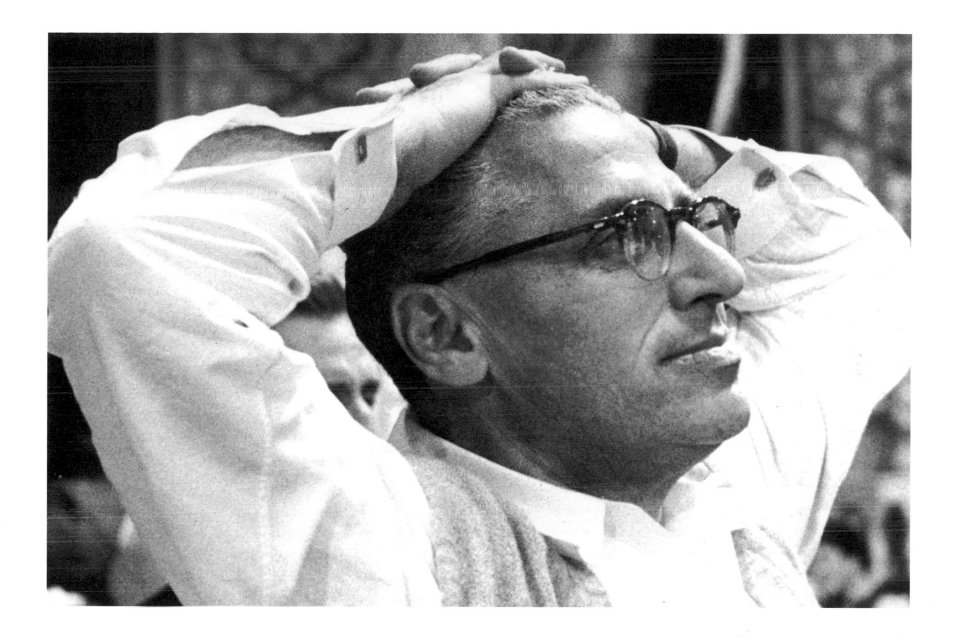

George Cukor

HOLLYWOOD

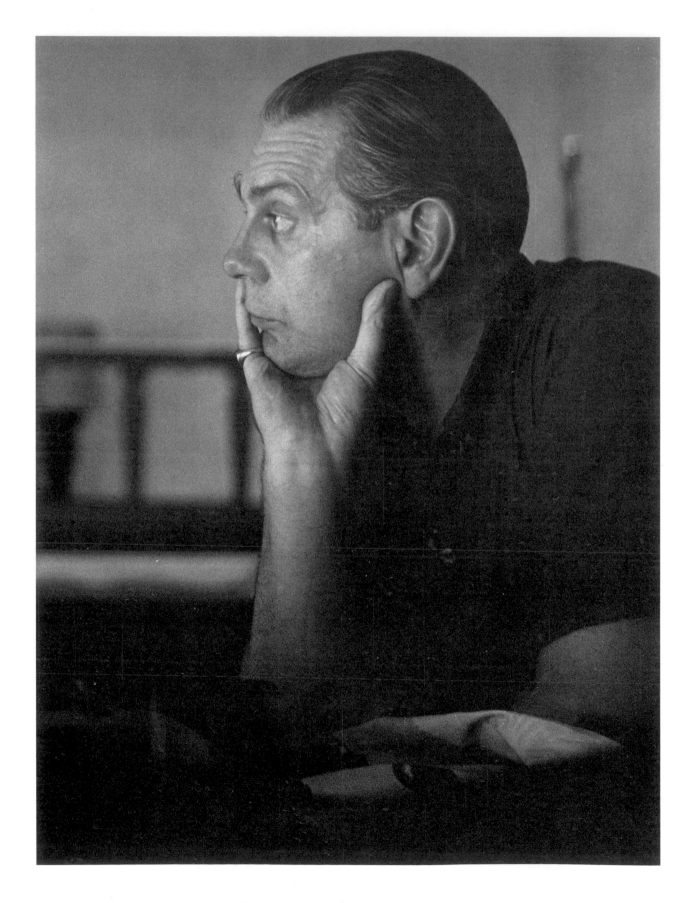

Raymond Massey

HOLLYWOOD

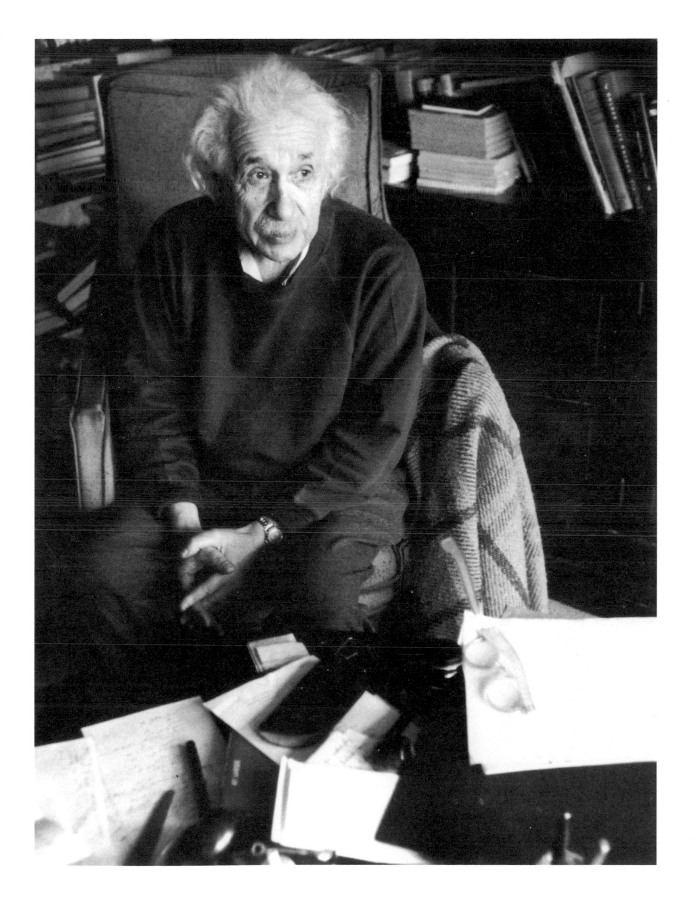

Albert Einstein

PRINCETON, NEW JERSEY

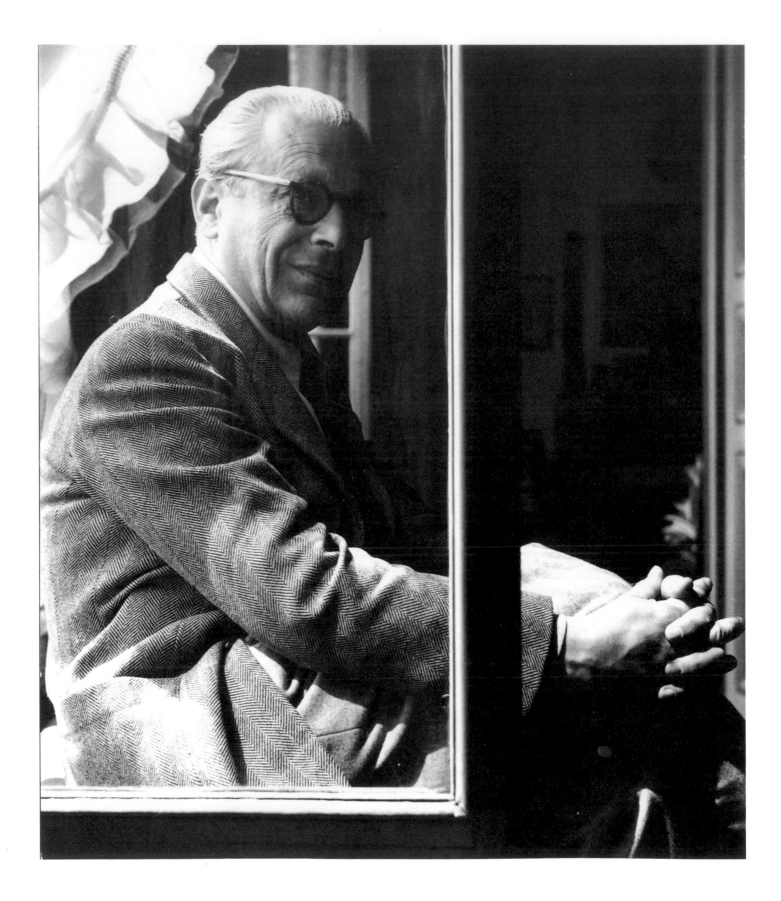

Tristan Tzara

PARIS

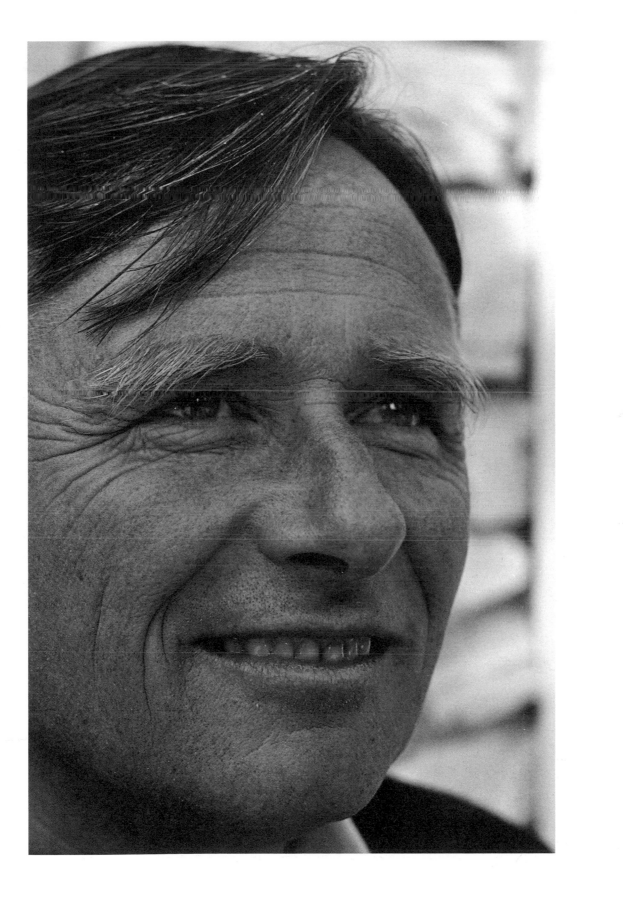

Christopher Isherwood

SANTA MONICA

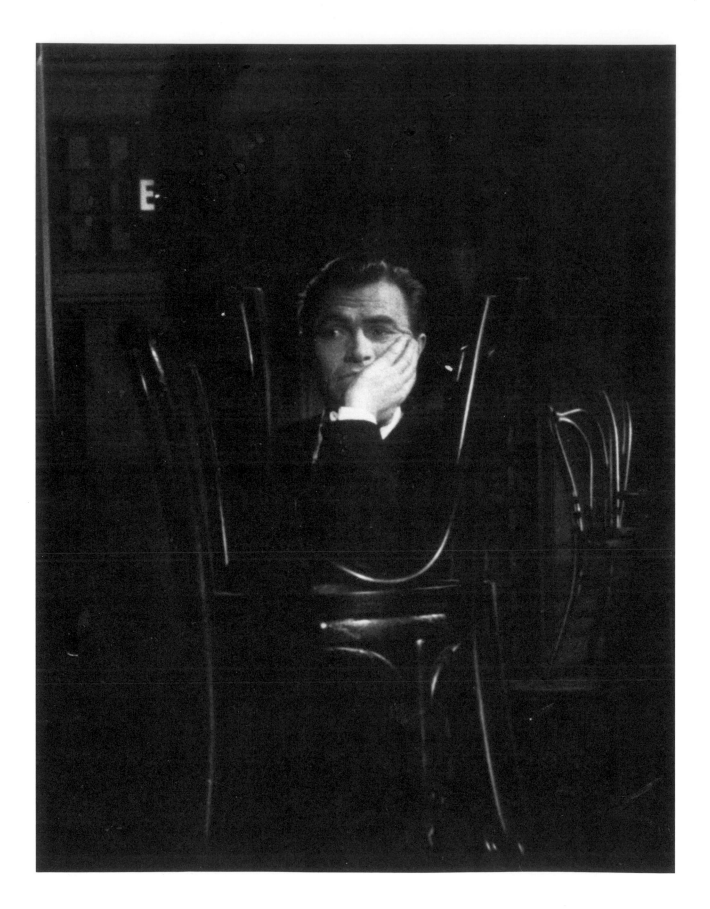

James Mason

LOS ANGELES

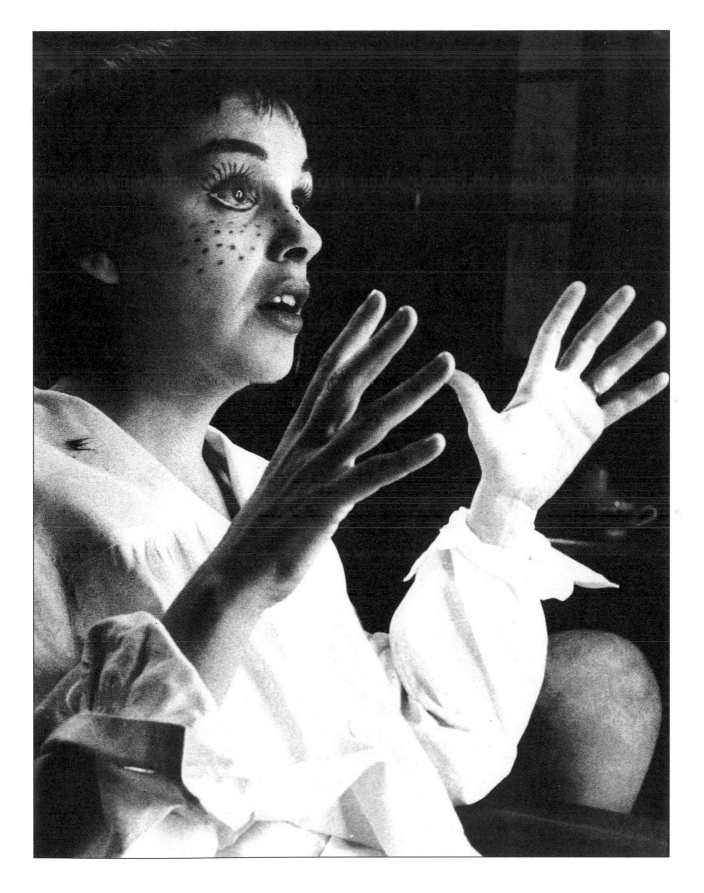

Judy Garland

HOLLYWOOD

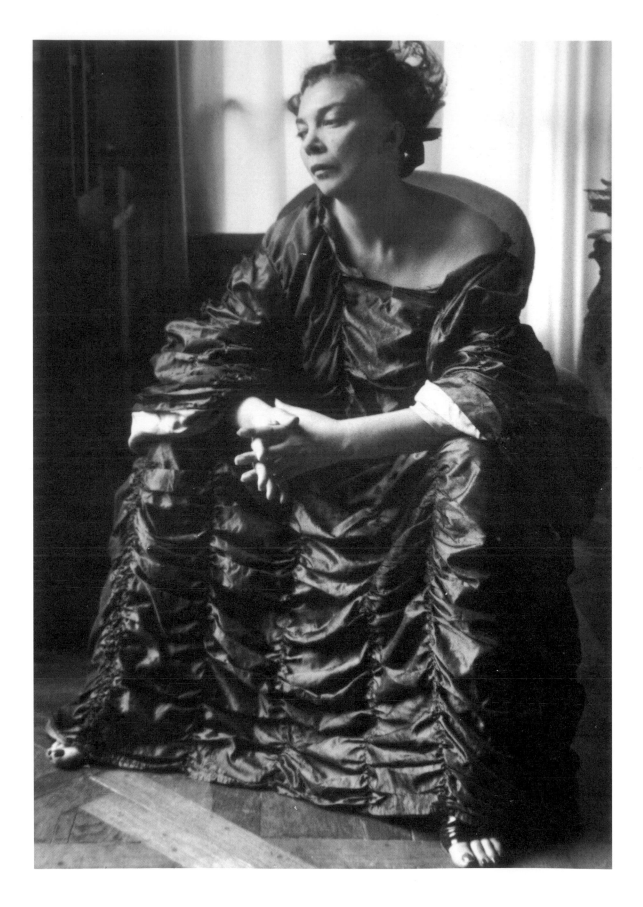

Leonor Fini

PARIS

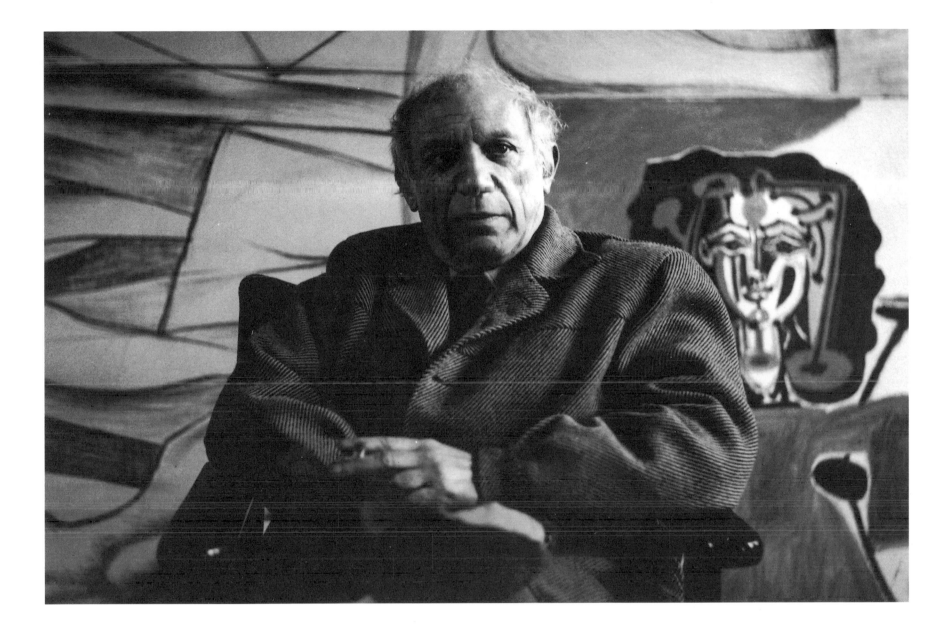

Pablo Picasso

PARIS

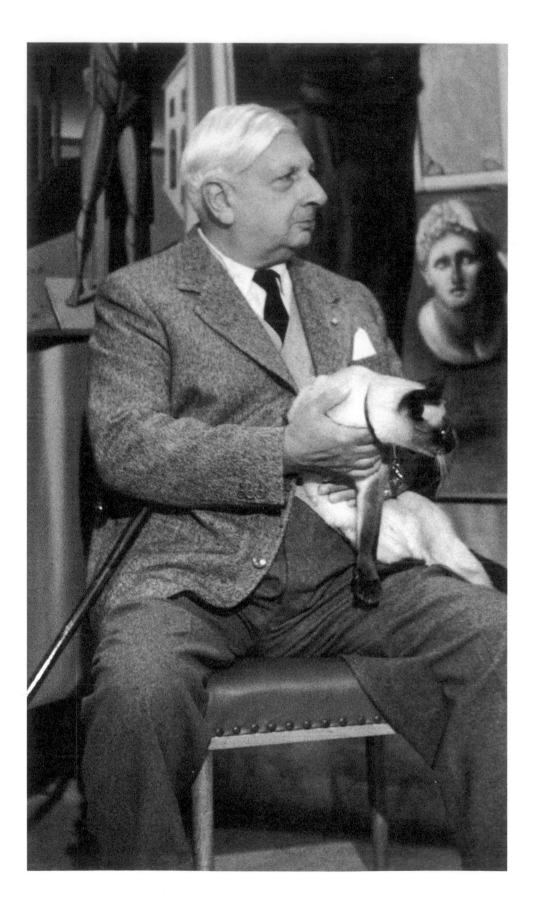

Giorgio de Chirico

VENICE

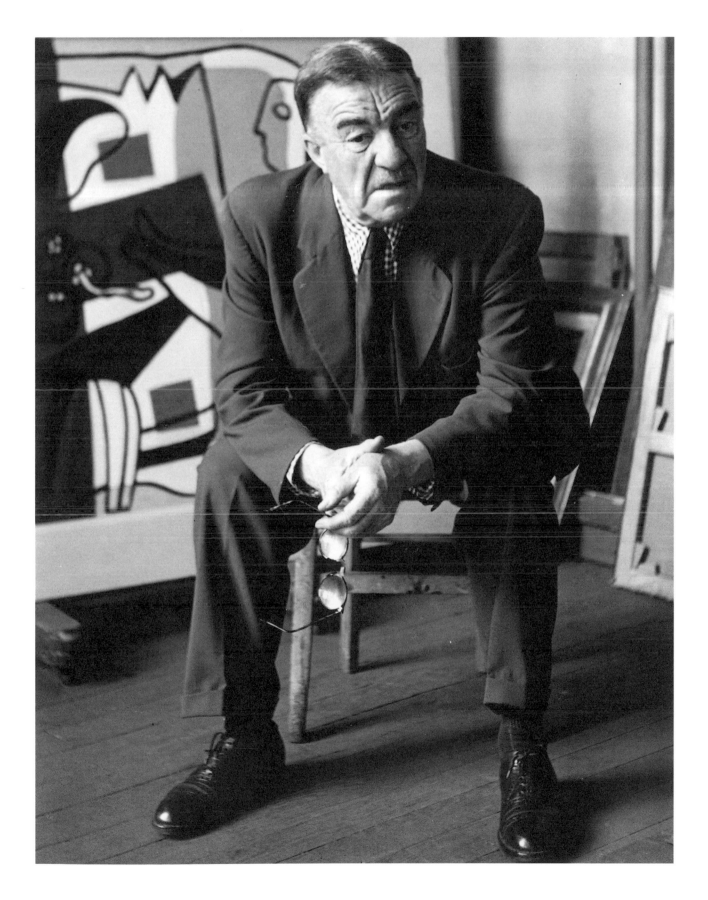

Fernand Léger

PARIS

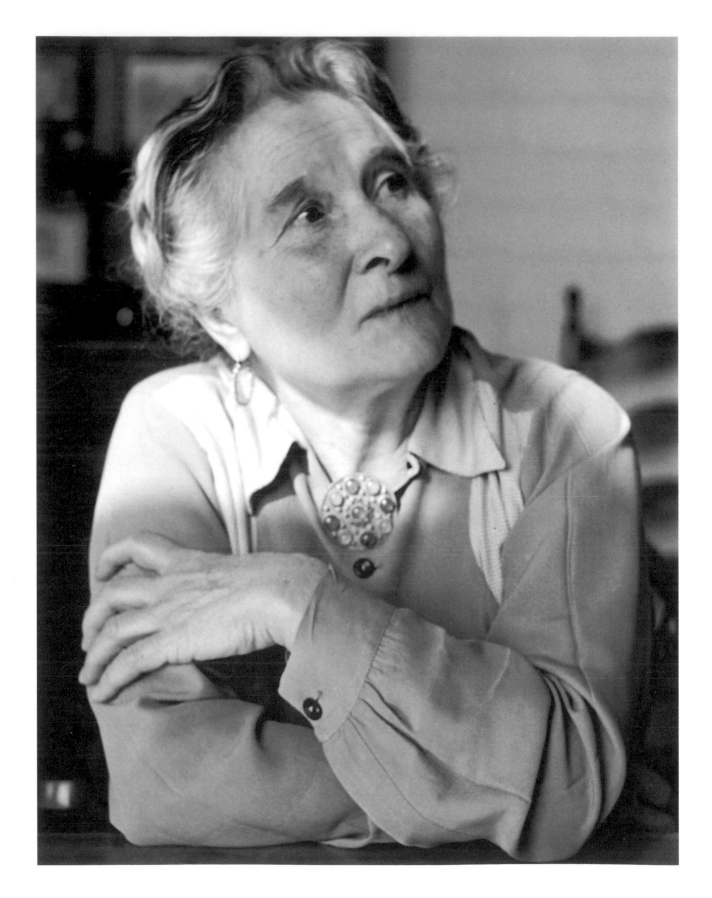

Gabrielle

BEVERLY HILLS

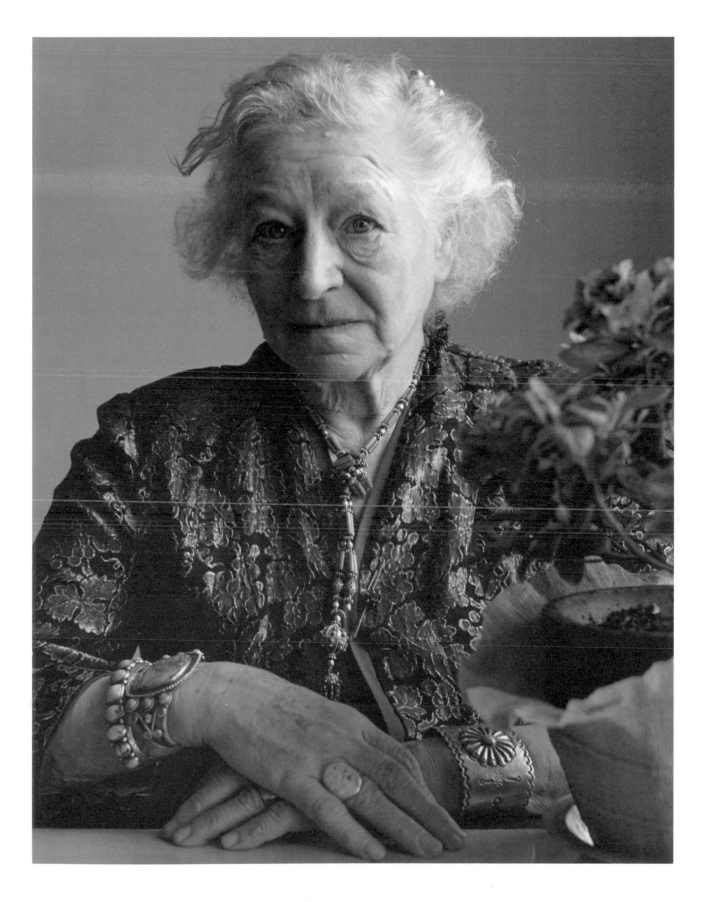

Frieda Lawrence
—
LOS ANGELES

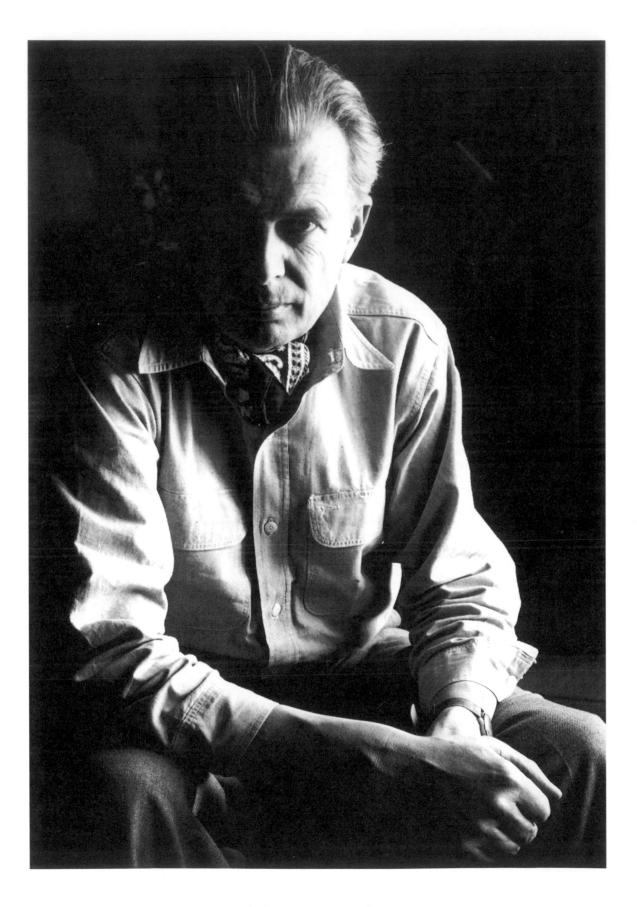

Aldous Huxley

HOLLYWOOD

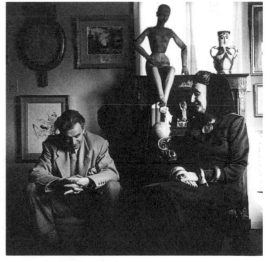

Huxley and Sitwell, Hollywood

Edith Sitwell

HOLLYWOOD

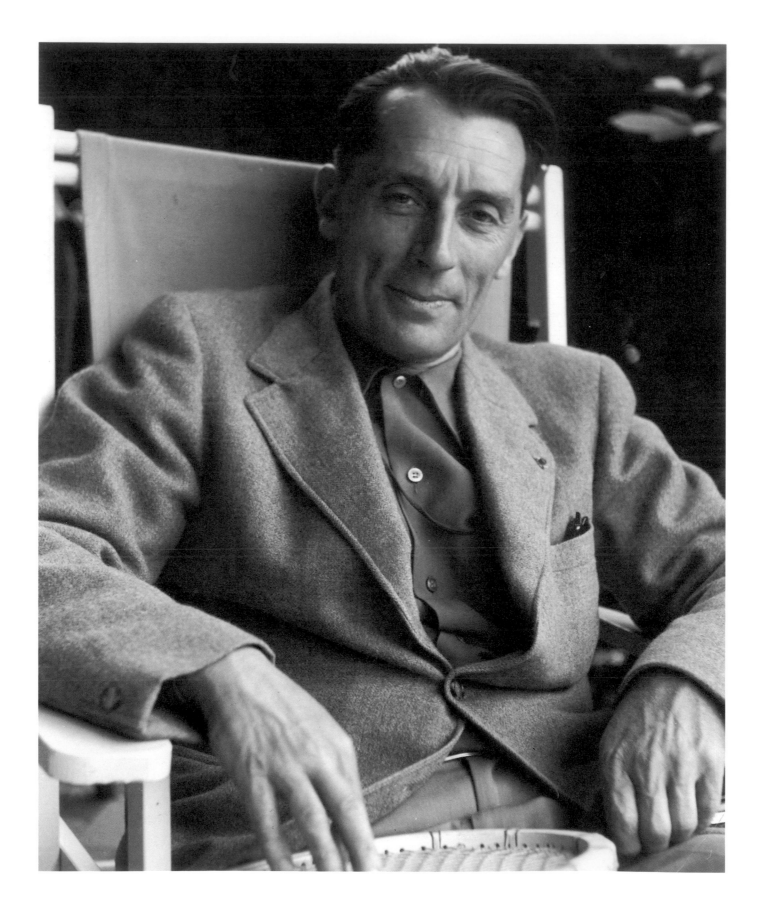

Frédéric Joliot-Curie

ANTONY, FRANCE

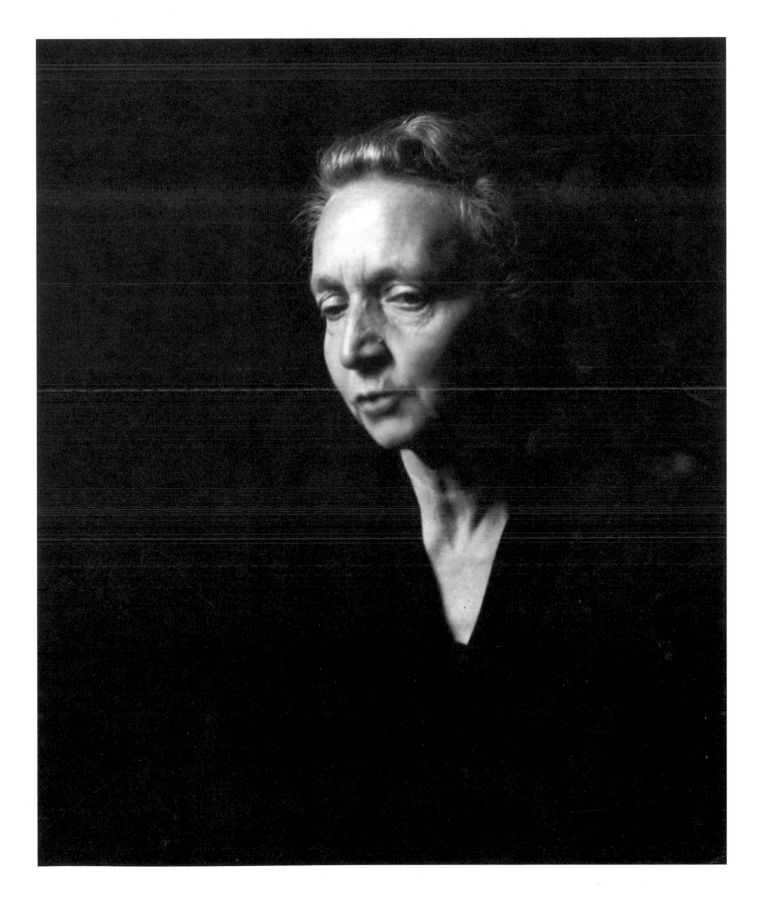

Irène Joliot-Curie

PARIS

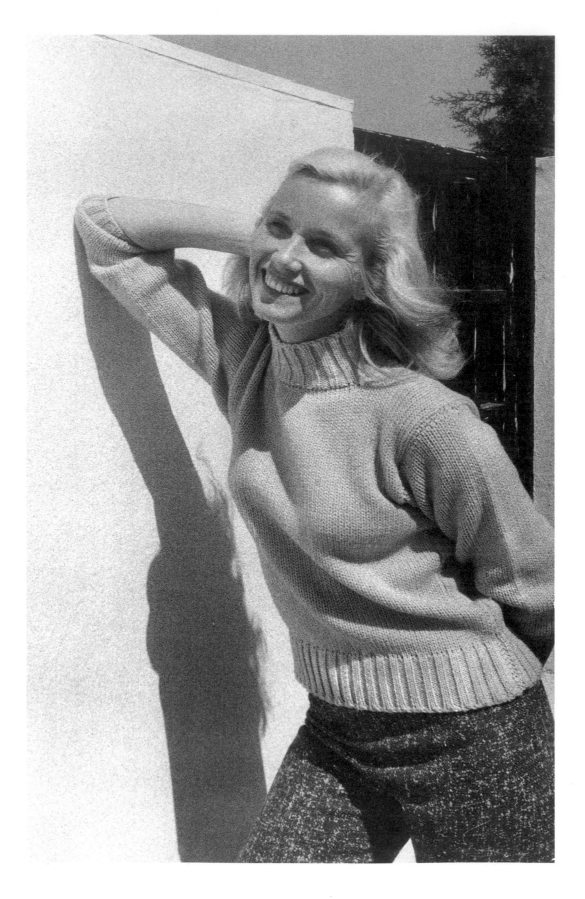

Eva Marie Saint

HOLLYWOOD

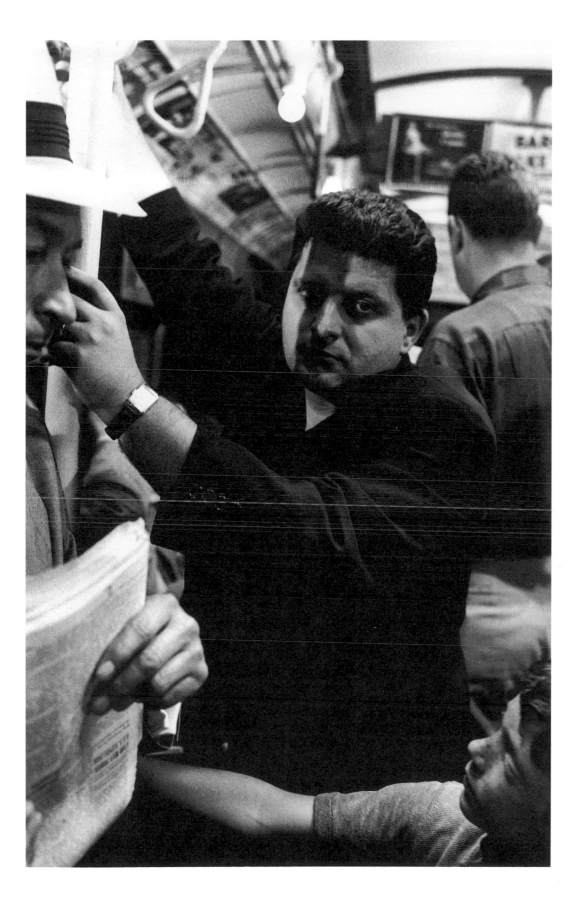

Paddy Chayefsky
NEW YORK

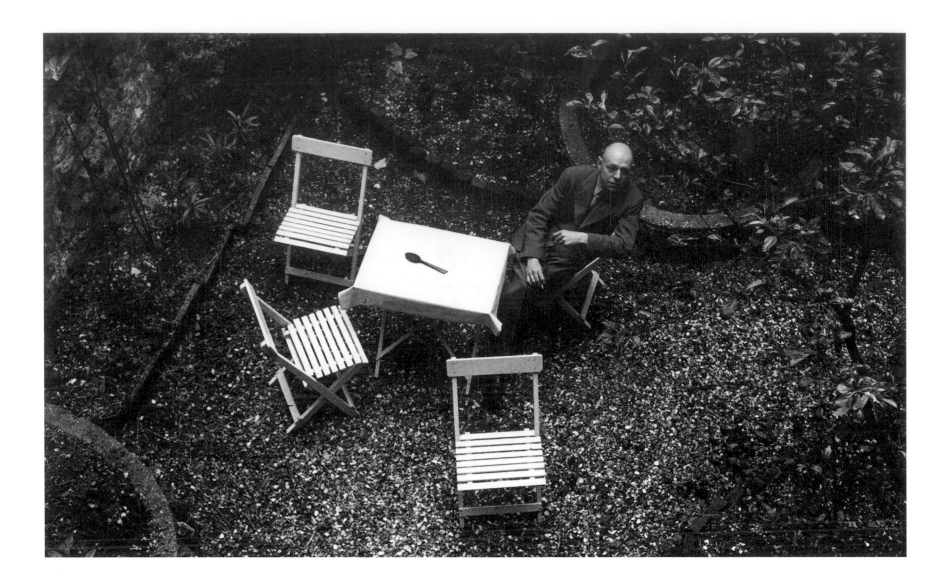

Jean Dubuffet

PARIS

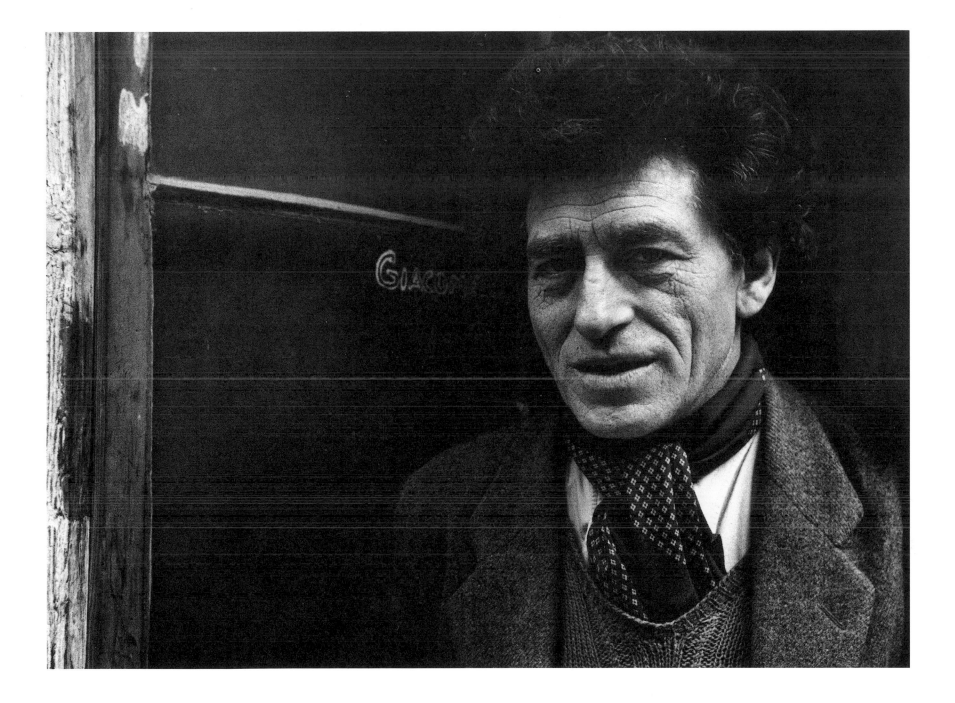

Alberto Giacometti

PARIS

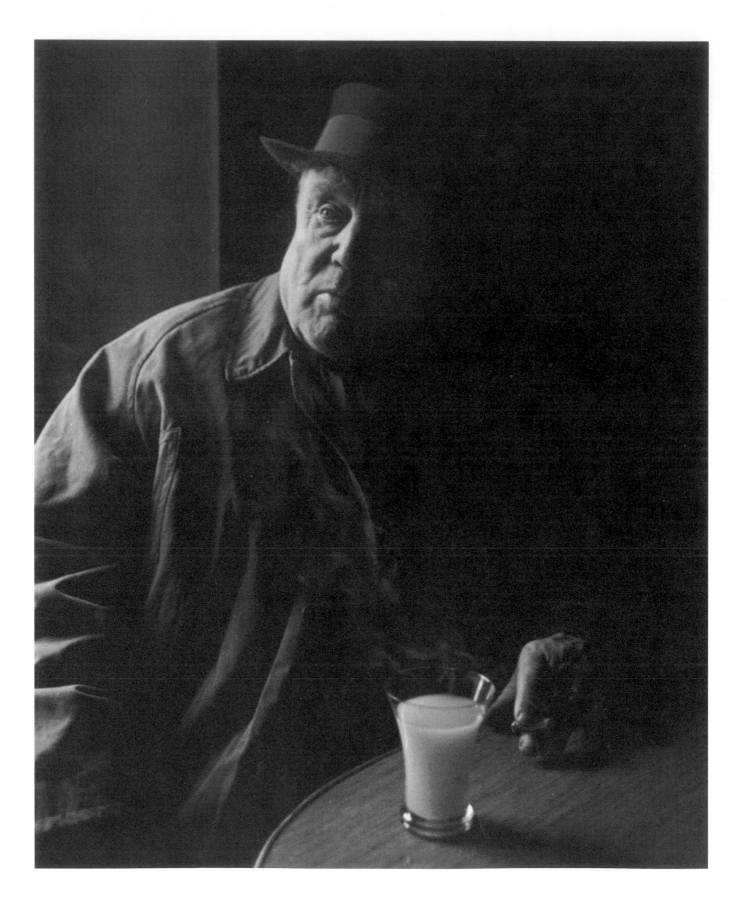

Maurice de Vlaminck

VERNEUIL, FRANCE

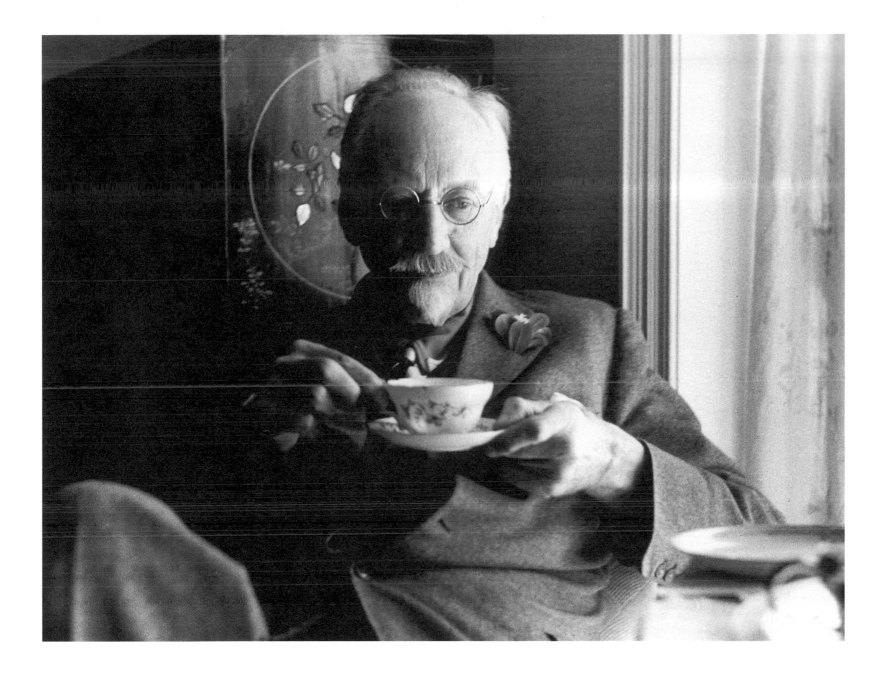

Lord Dunsany

PALOS VERDES, CALIFORNIA

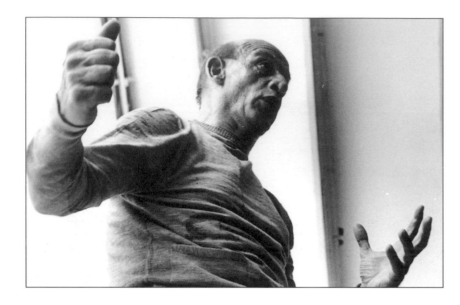
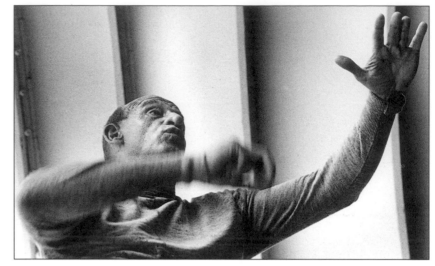
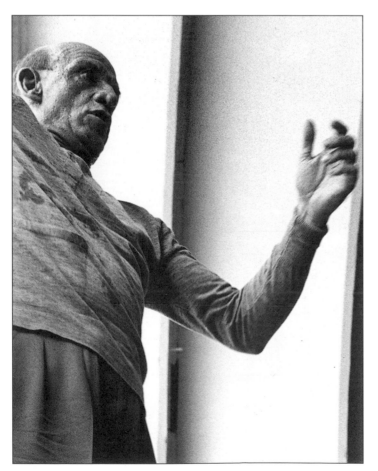
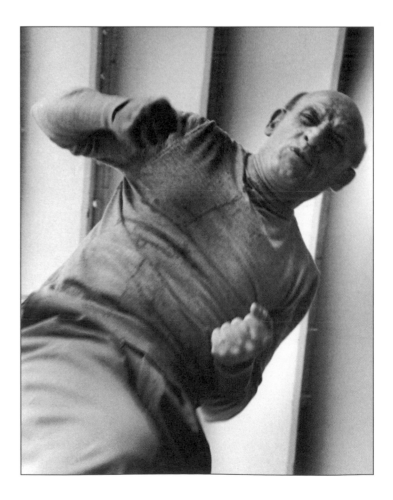

Dimitri Mitropoulos

HOLLYWOOD

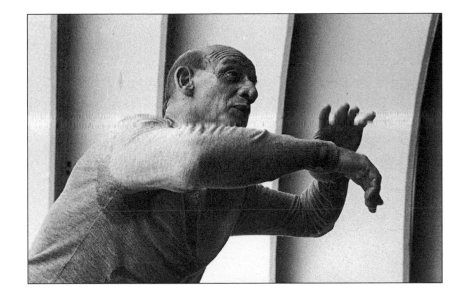
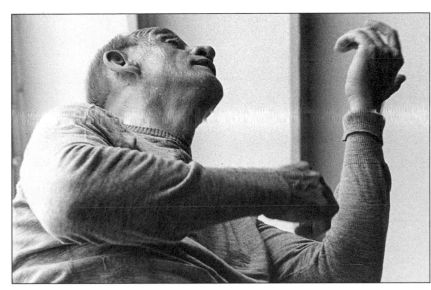
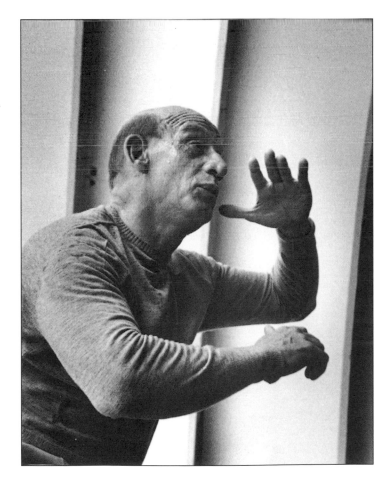
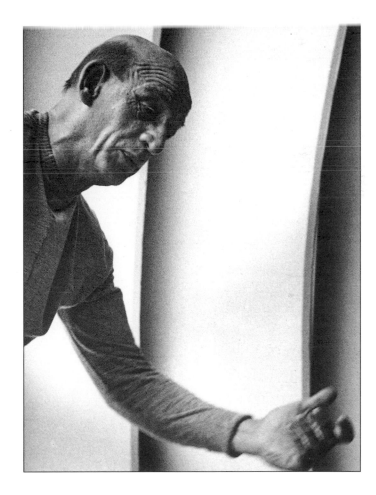

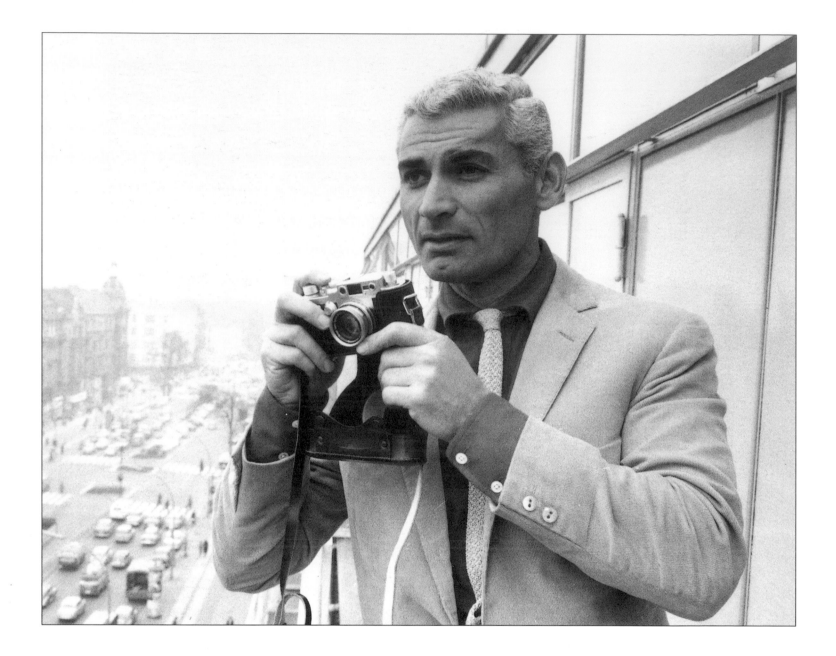

Jeff Chandler

BERLIN

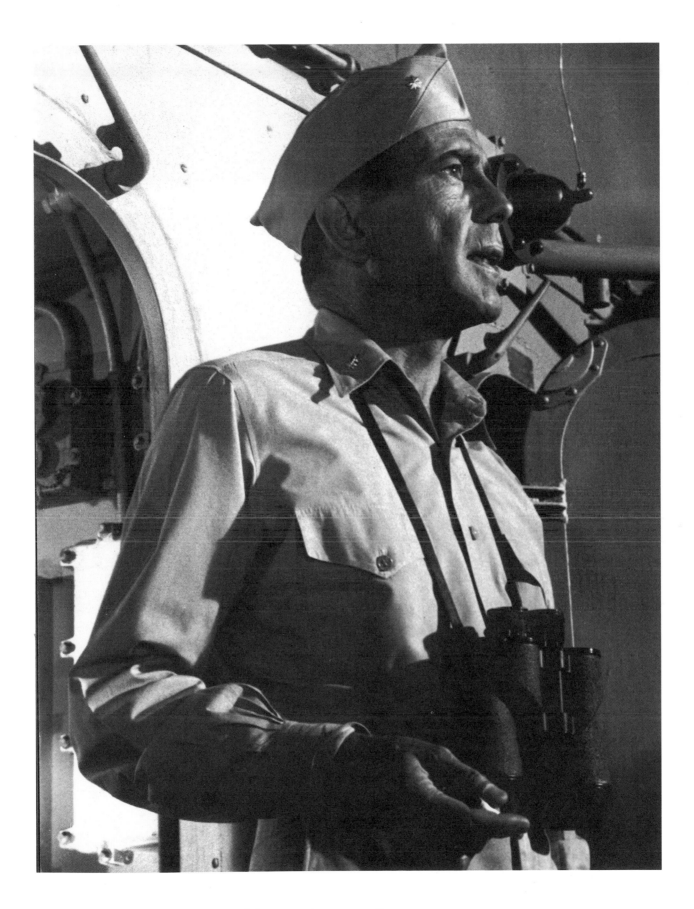

Humphrey Bogart

HOLLYWOOD

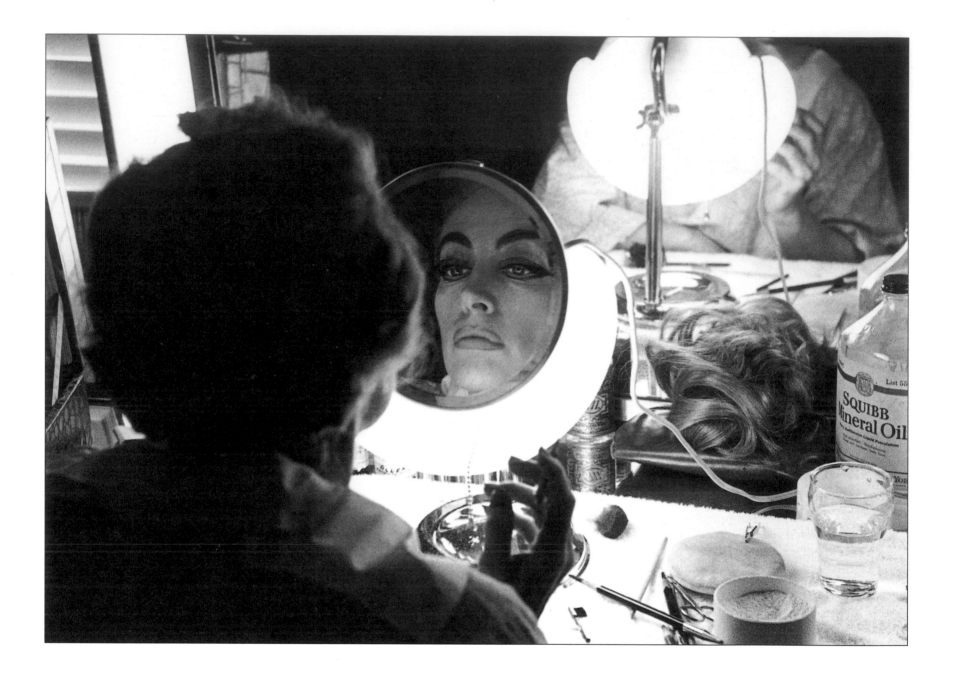

58

Joan Crawford

HOLLYWOOD

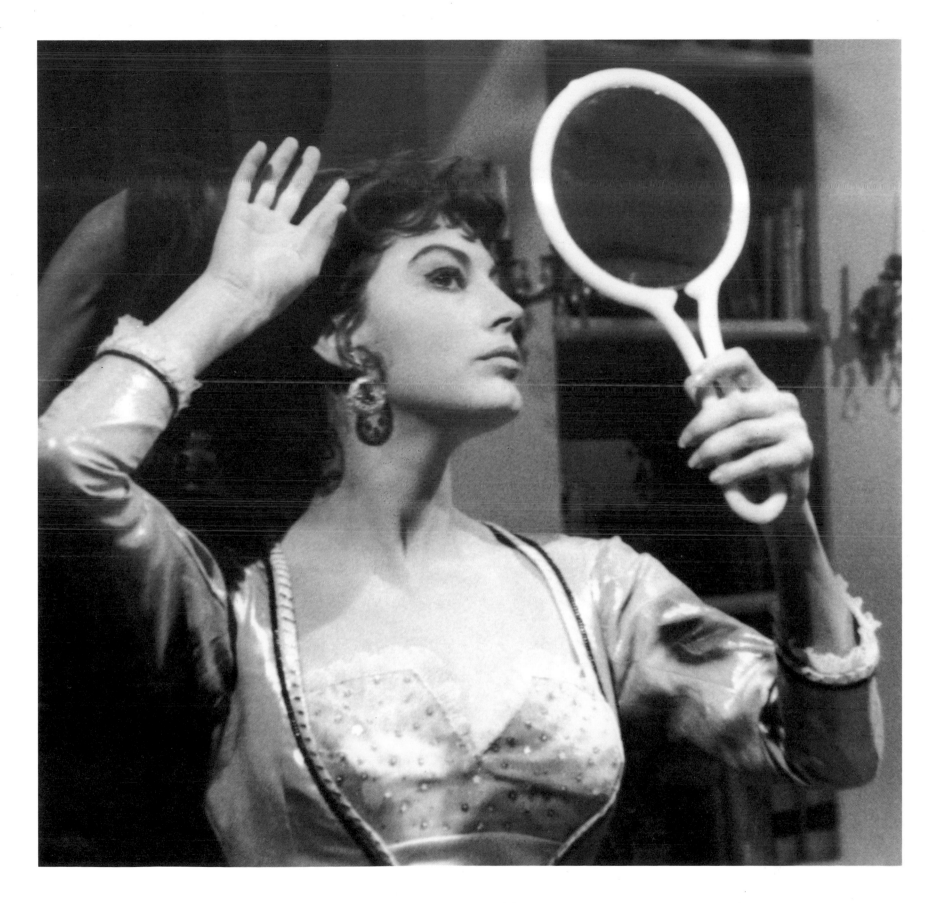

Ava Gardner

ROME

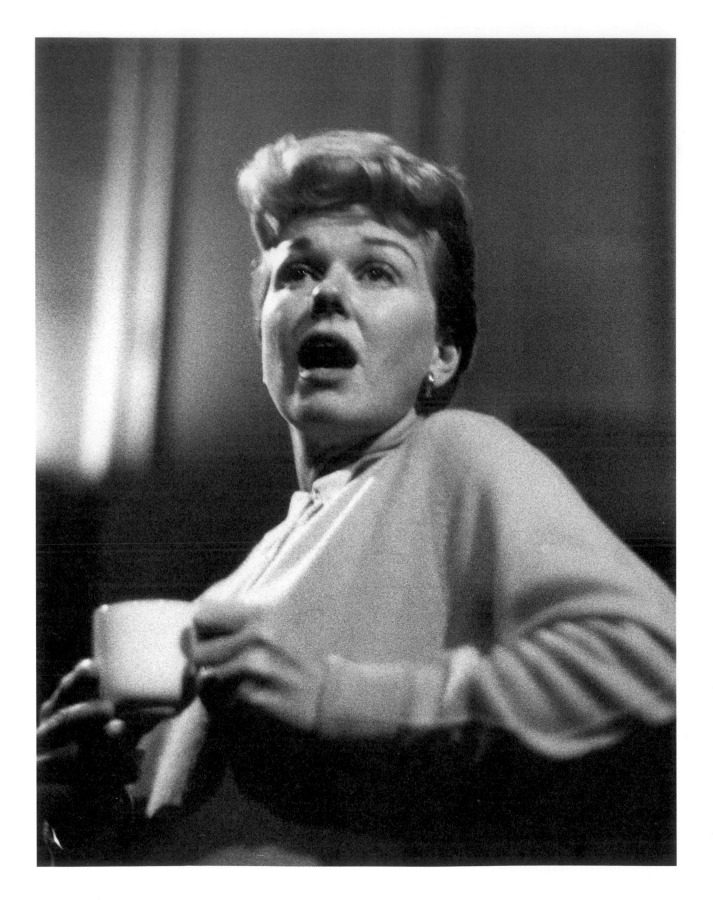

Doris Day

LONDON

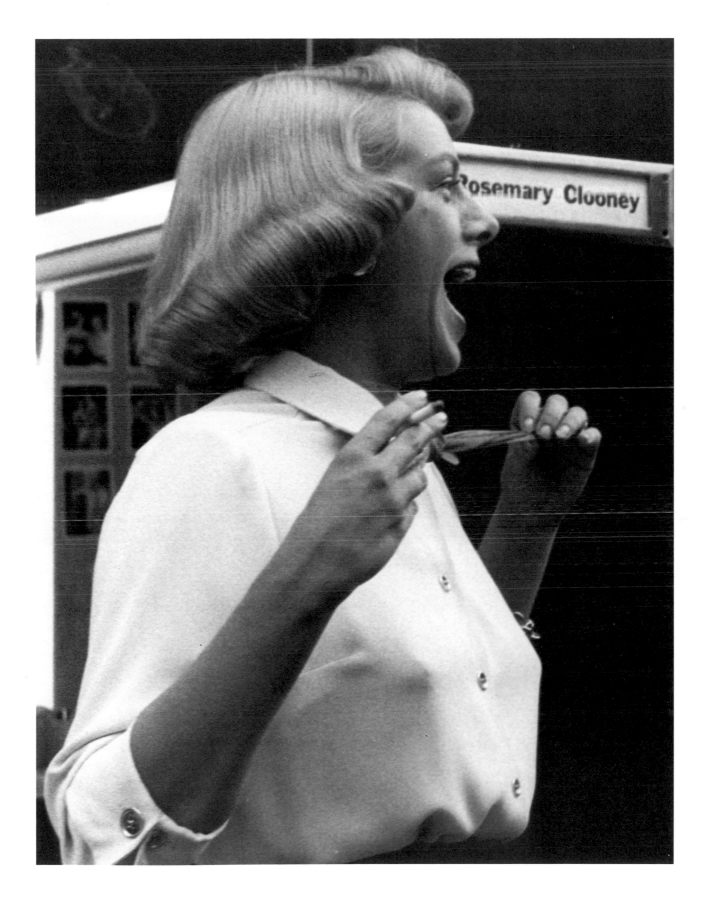

Rosemary Clooney

LOS ANGELES

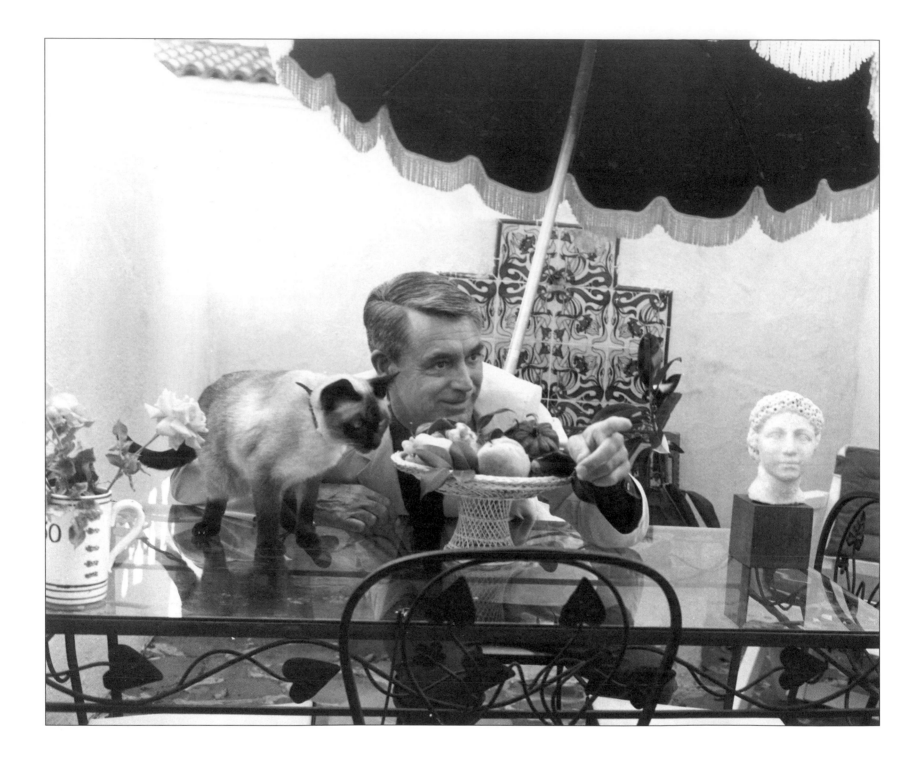

Cary Grant

BEVERLY HILLS

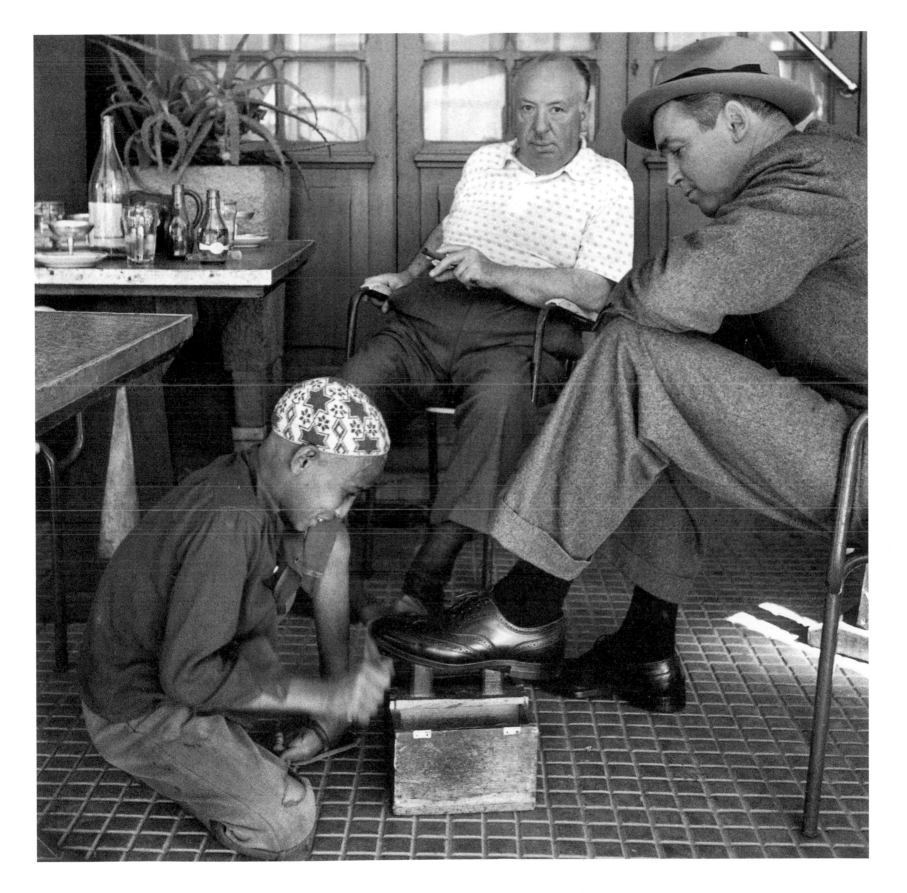

Alfred Hitchcock and James Stewart

MOROCCO

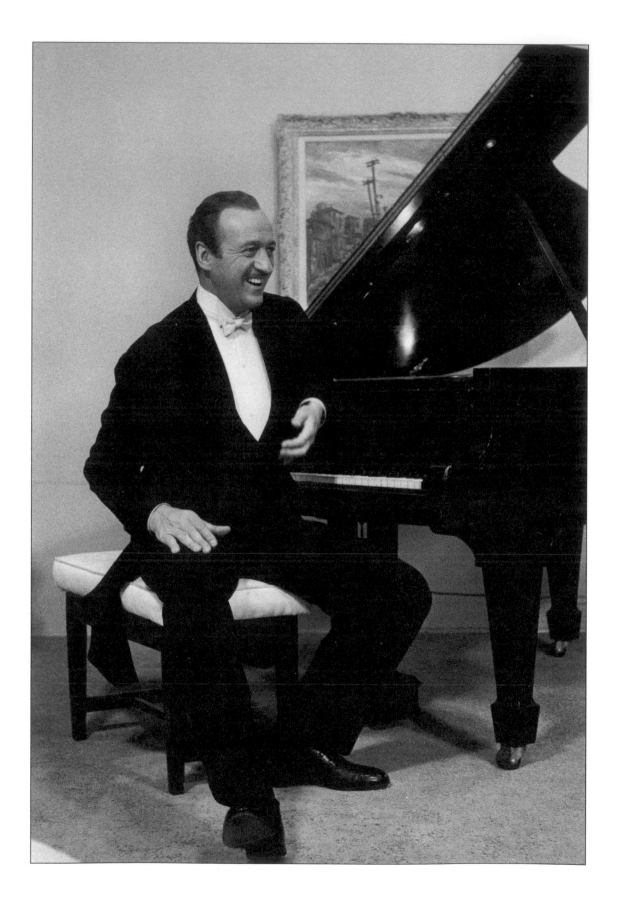

David Niven

HOLLYWOOD

Rock Hudson

LOS ANGELES

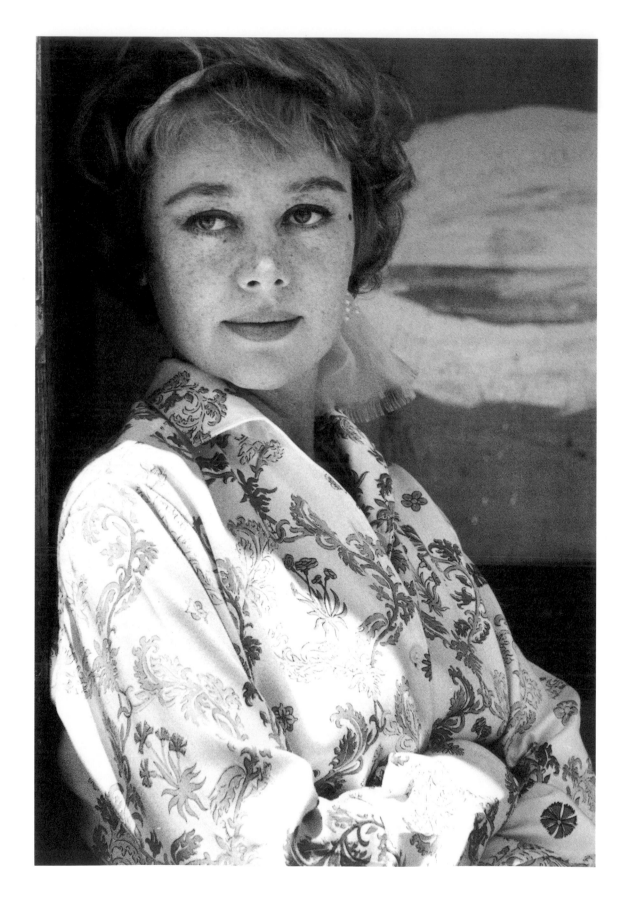

Glynis Johns

AUSTRALIA

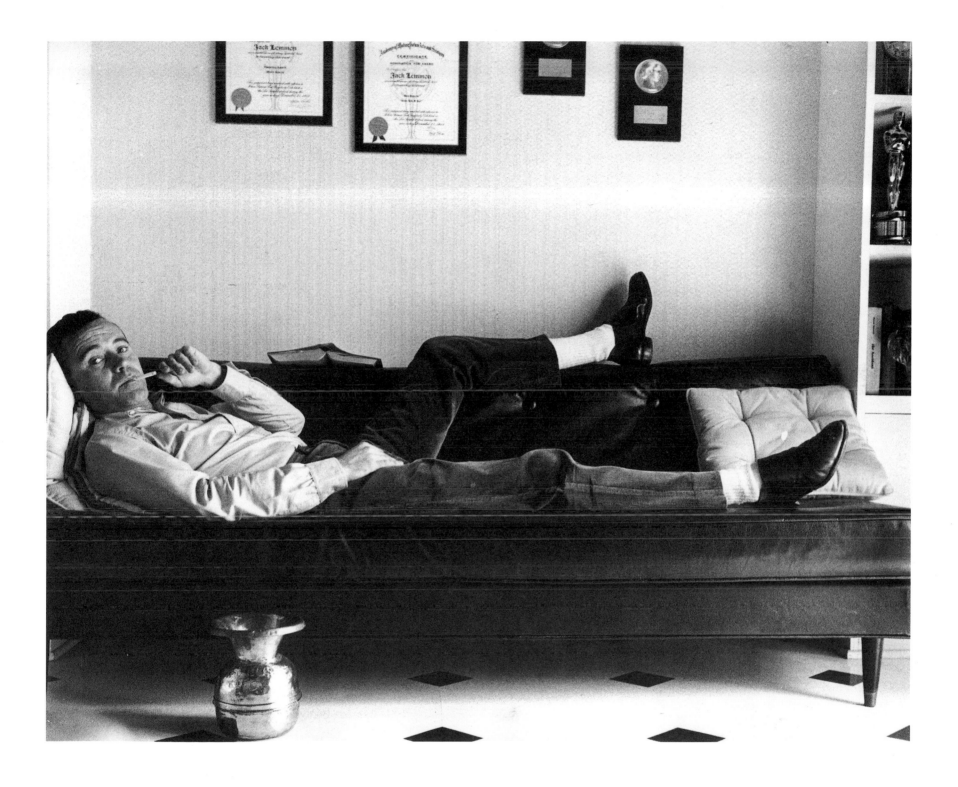

Jack Lemmon

BEVERLY HILLS

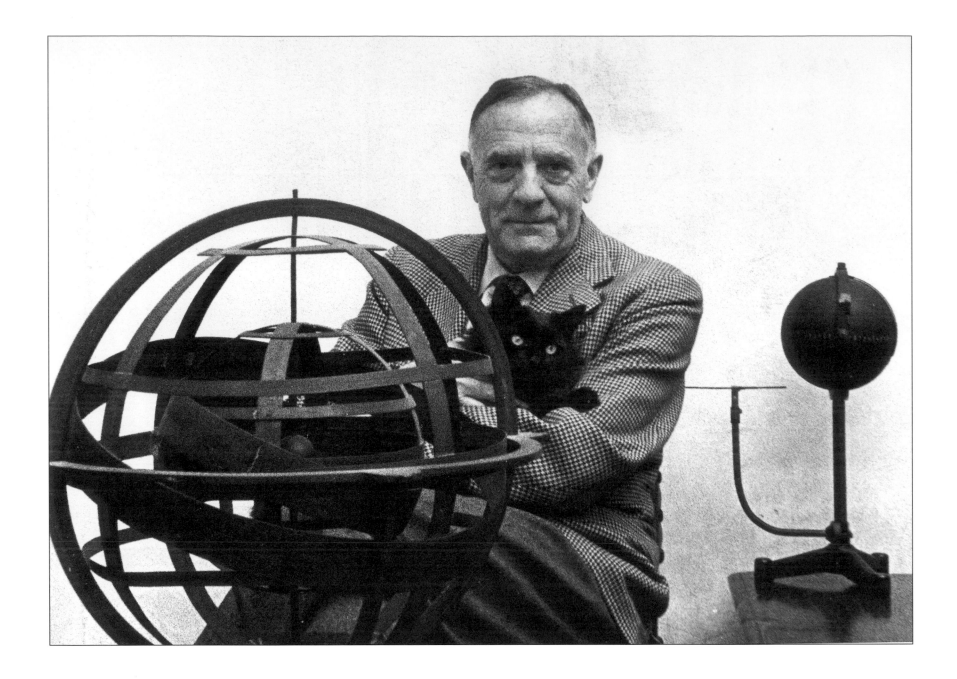

Edwin Hubble

PASADENA

Ruth St. Denis

NORTH HOLLYWOOD

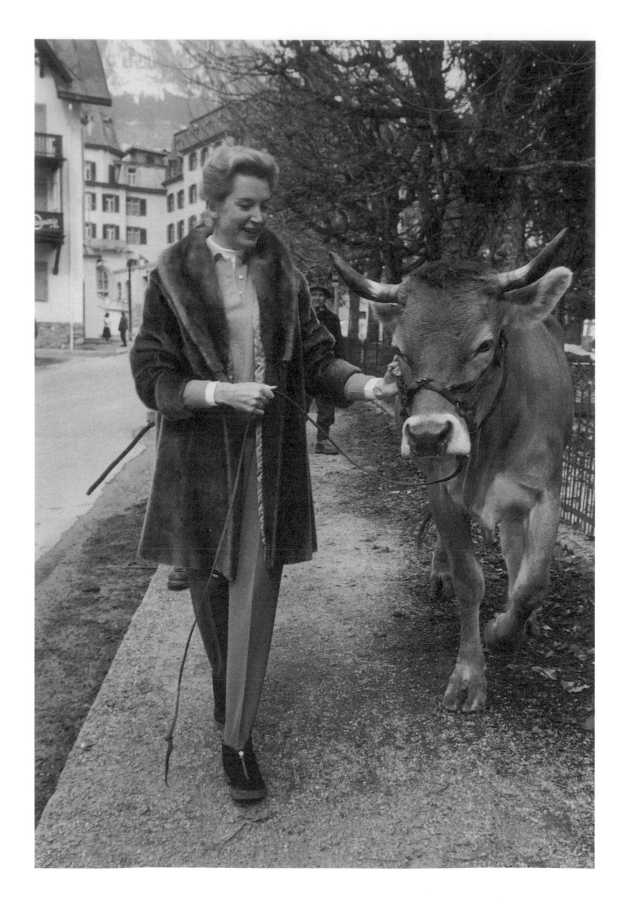

Deborah Kerr

GSTAAD, SWITZERLAND

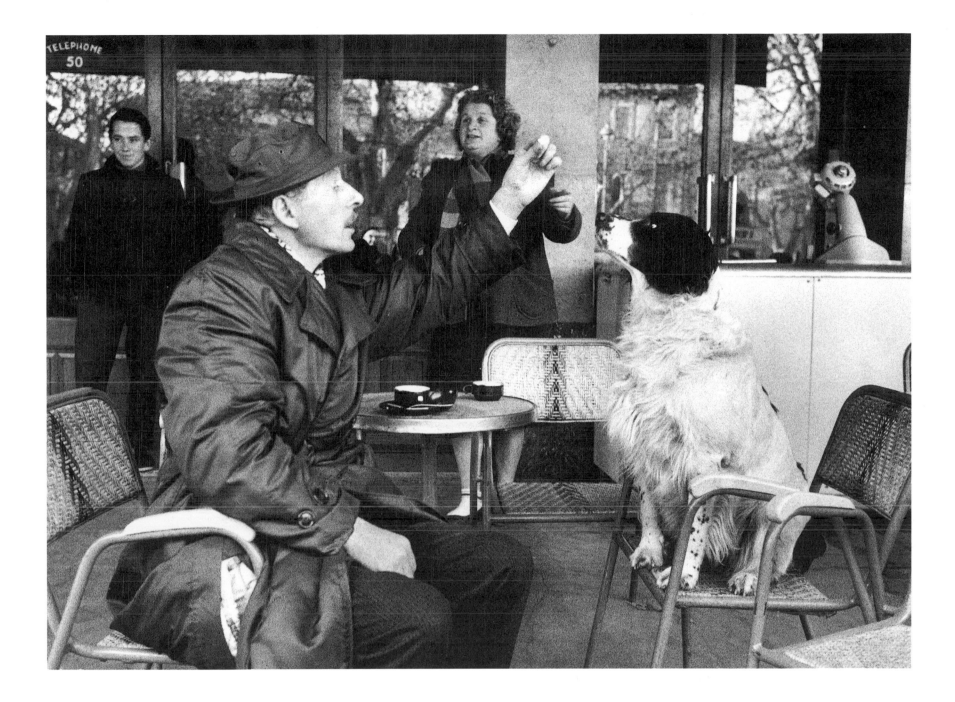

Danny Kaye

NÎMES, FRANCE

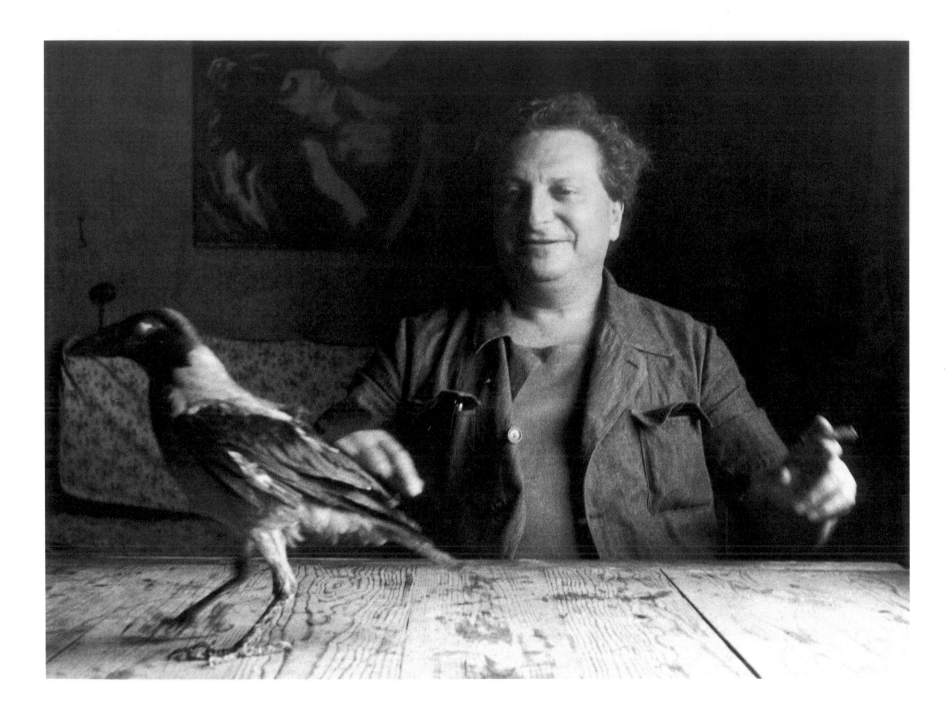

Carlo Levi

ROME

Georges Braque

VARENGEVILLE, FRANCE

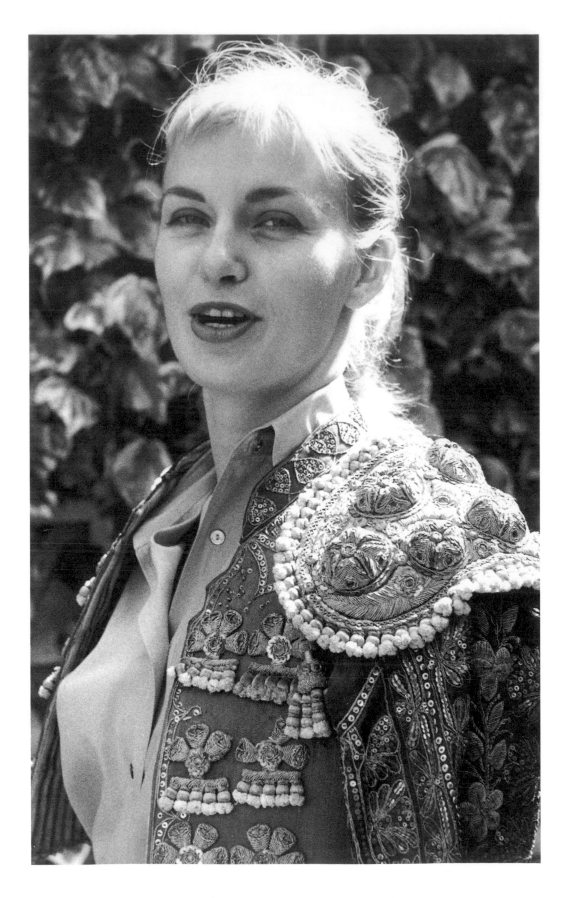

Joanne Woodward

HOLLYWOOD

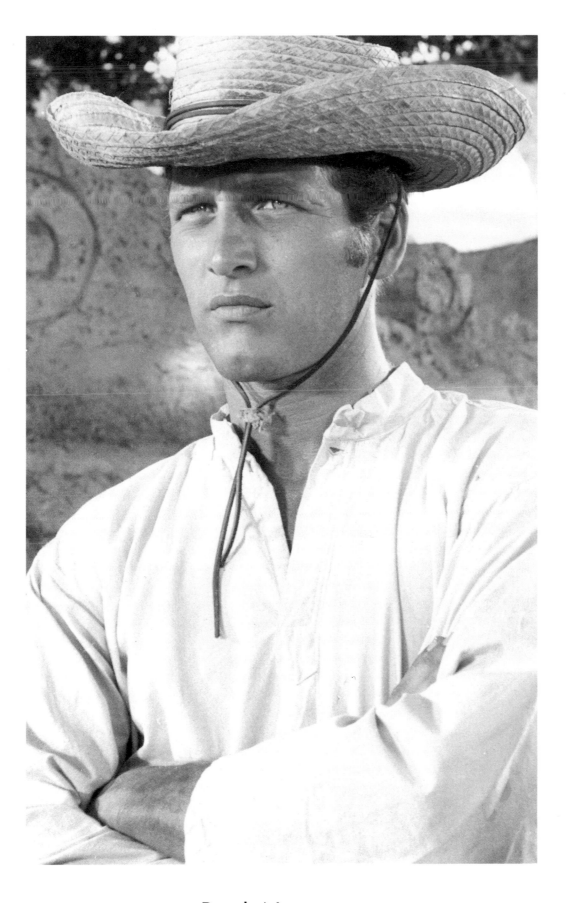

Paul Newman

HOLLYWOOD

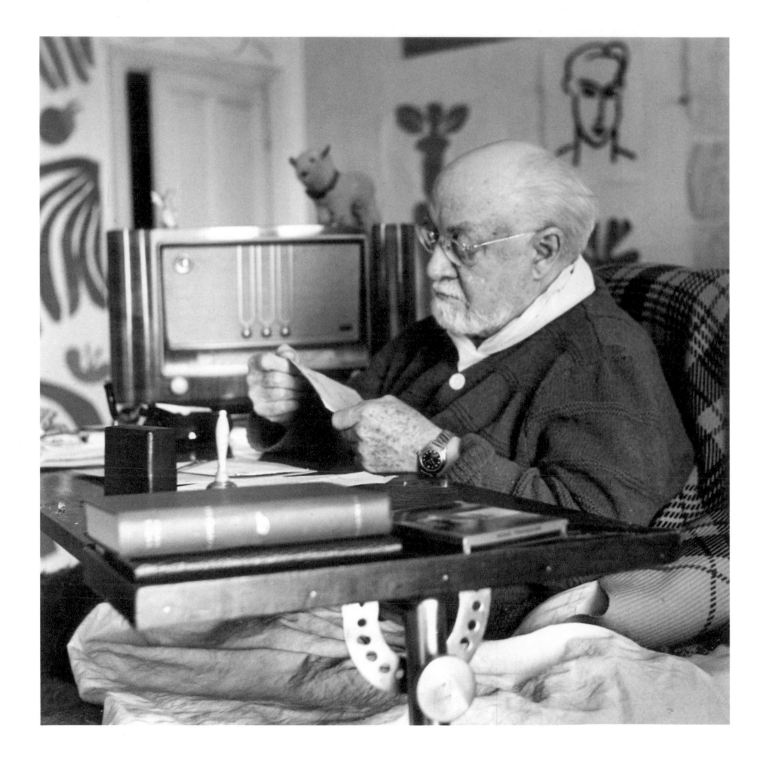

Henri Matisse

NICE

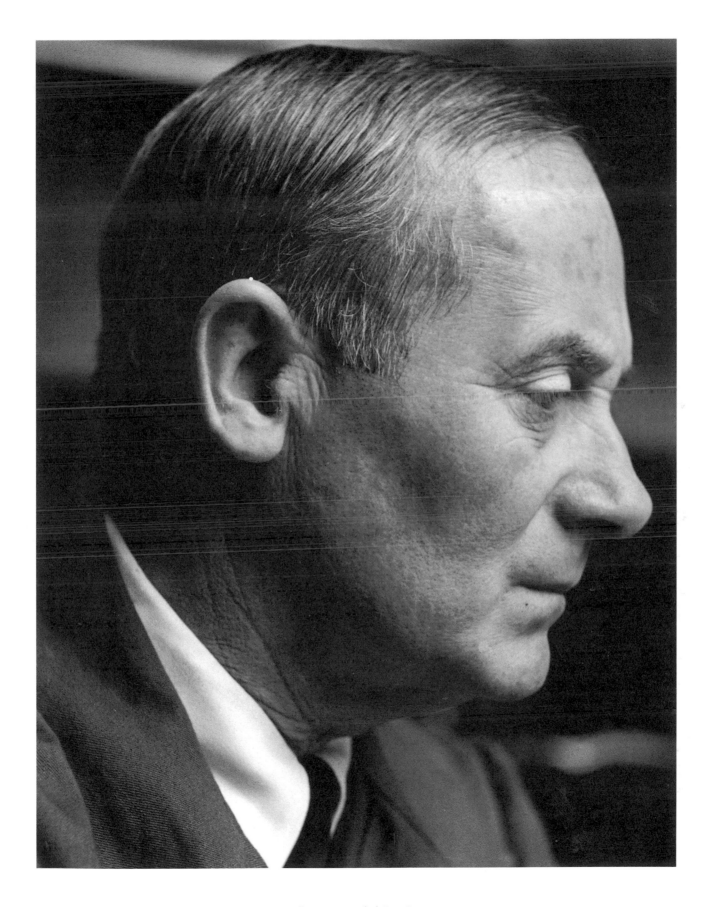

Joan Miró

PARIS

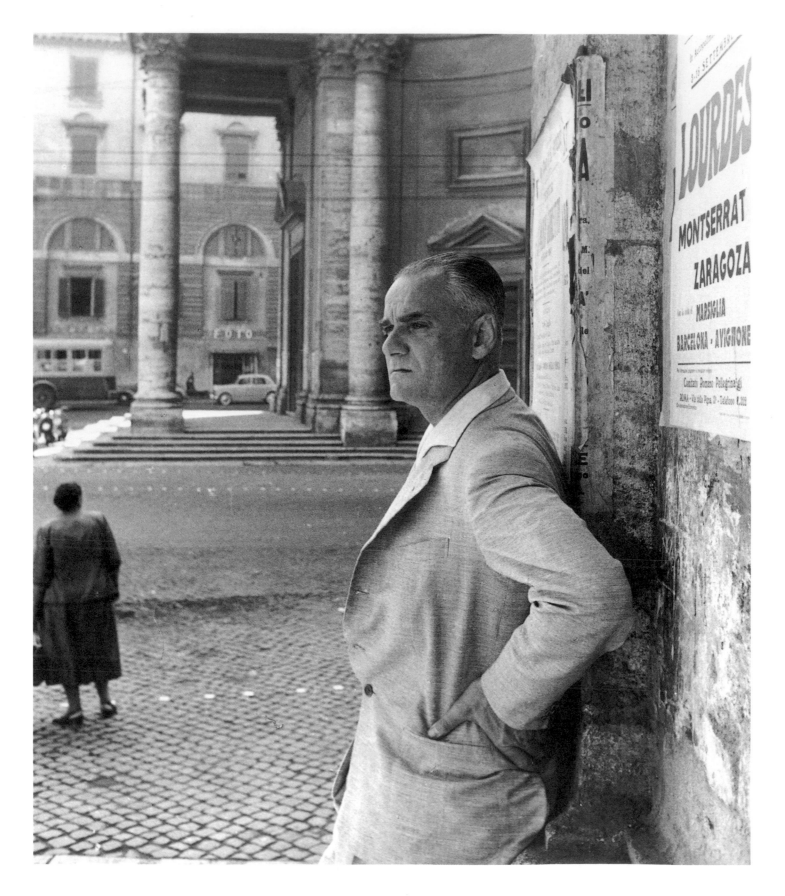

Alberto Moravia

ROME

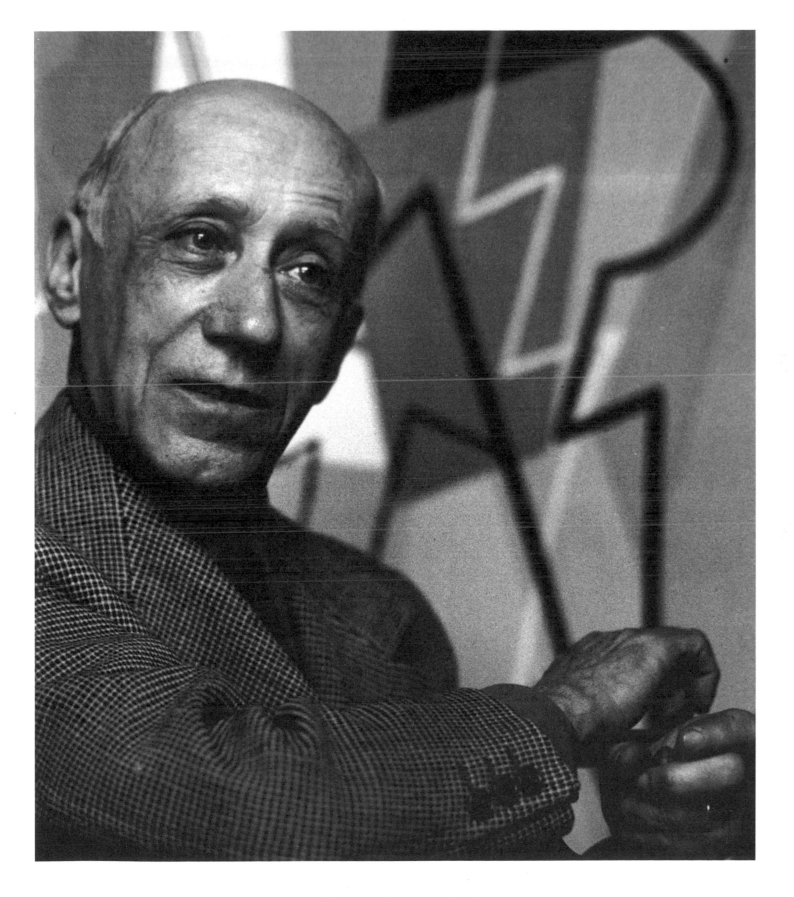

Gino Severini

PARIS

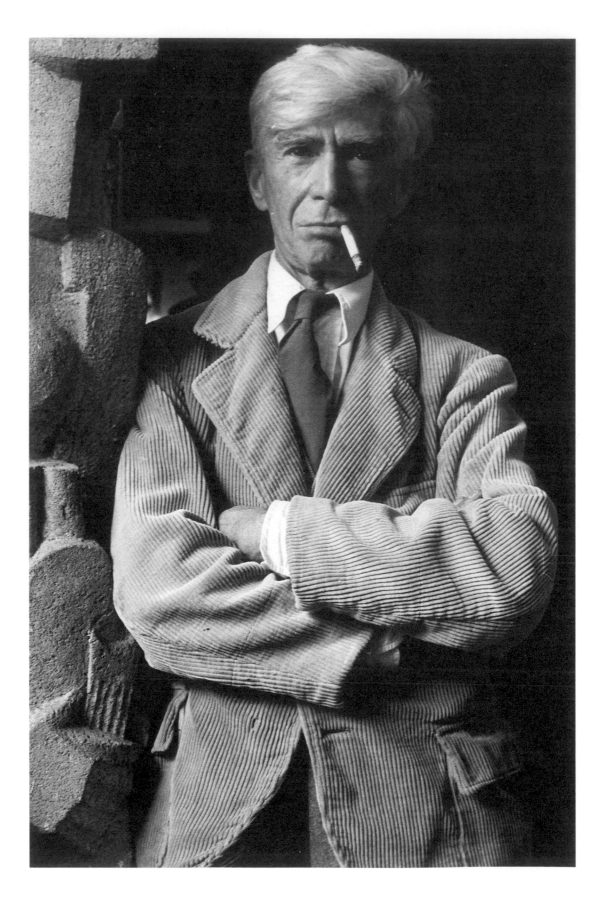

Ossip Zadkine

PARIS

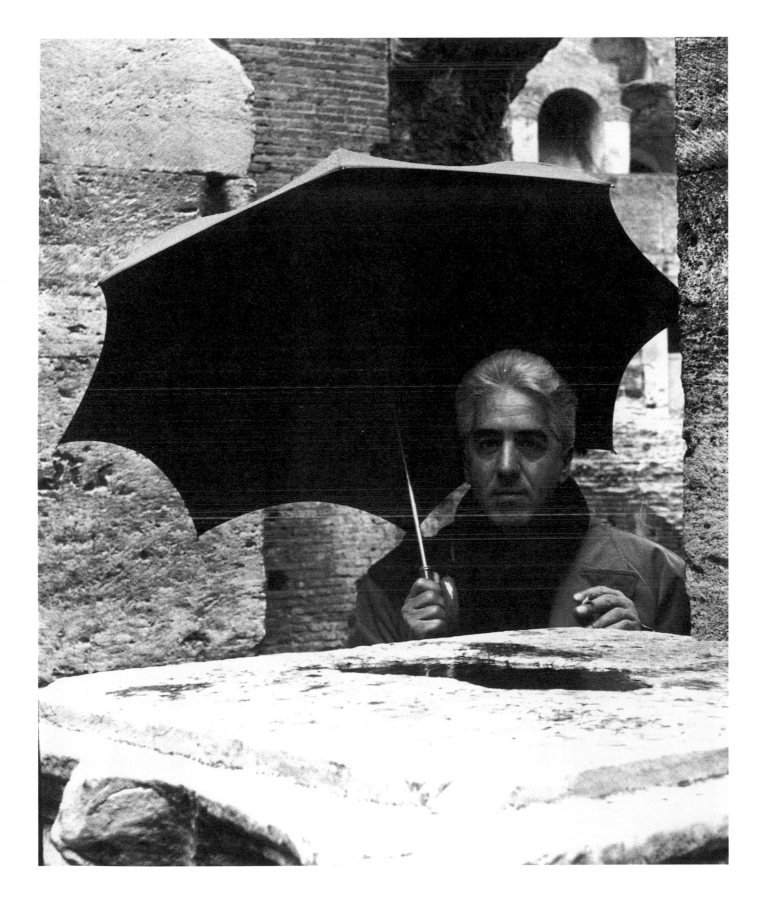

Afro

ROME

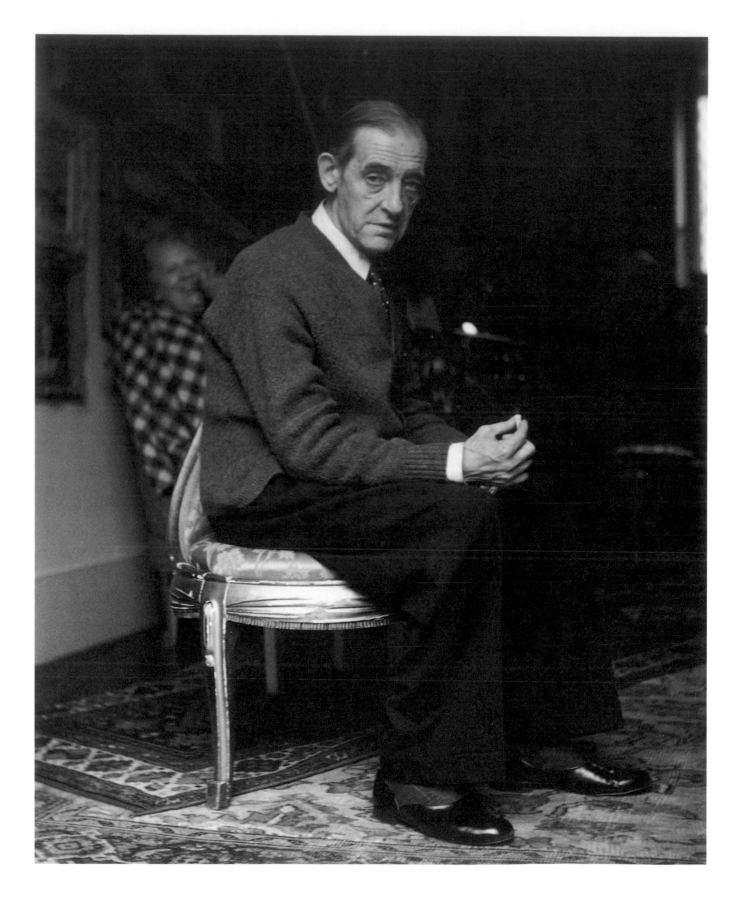

Maurice Utrillo

LE VÉSINET, FRANCE

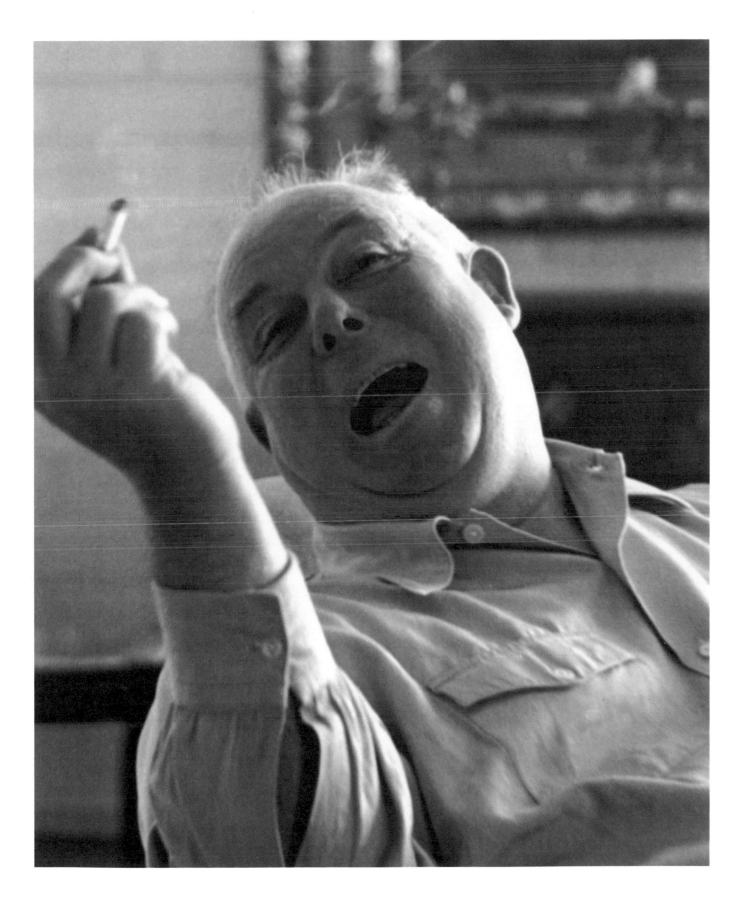

Jean Renoir

BEVERLY HILLS

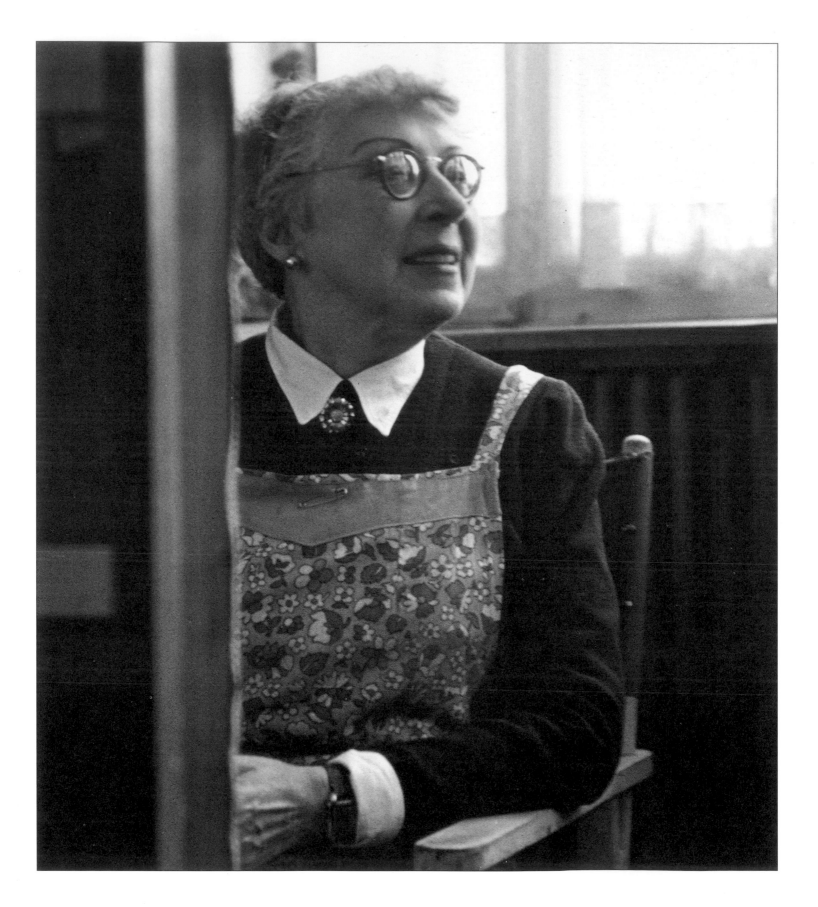

Marie Laurencin

PARIS

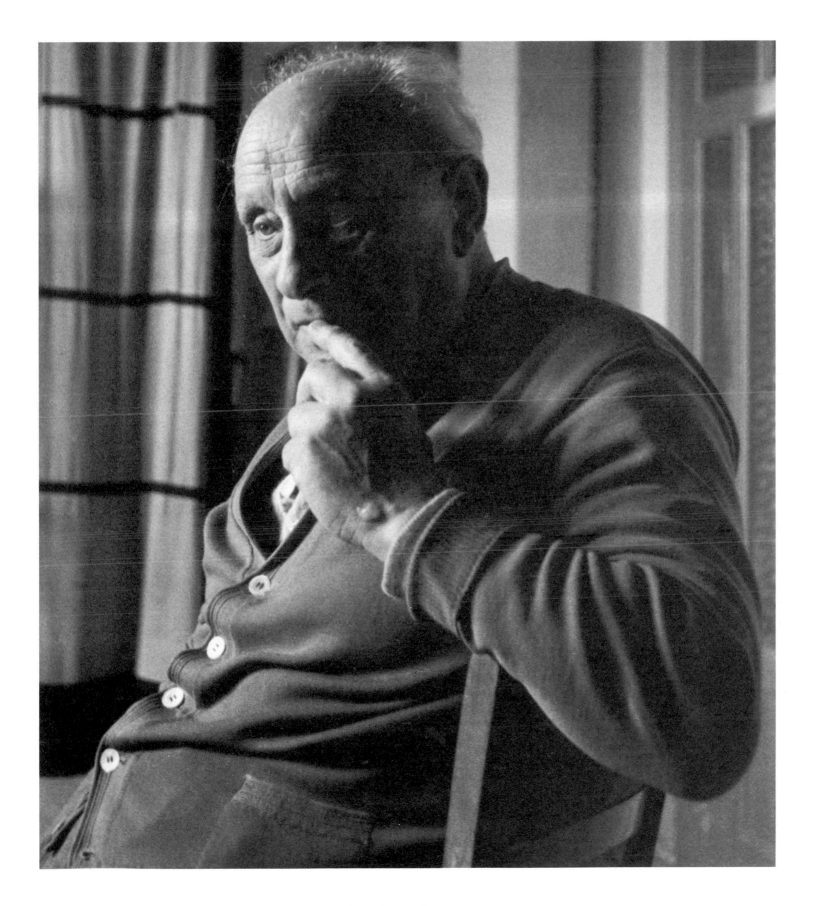

Carlo Carra

MILAN

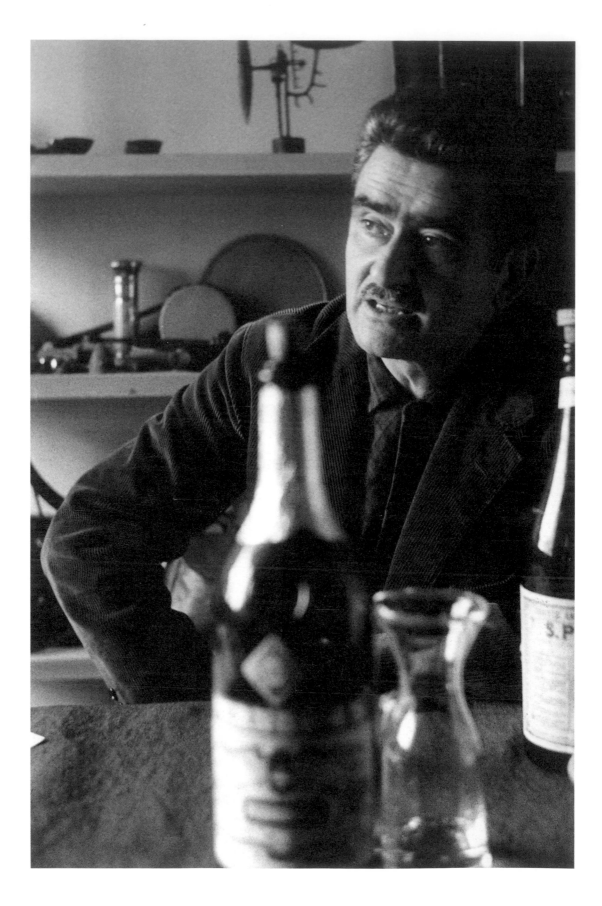

Alberto Burri

ROME

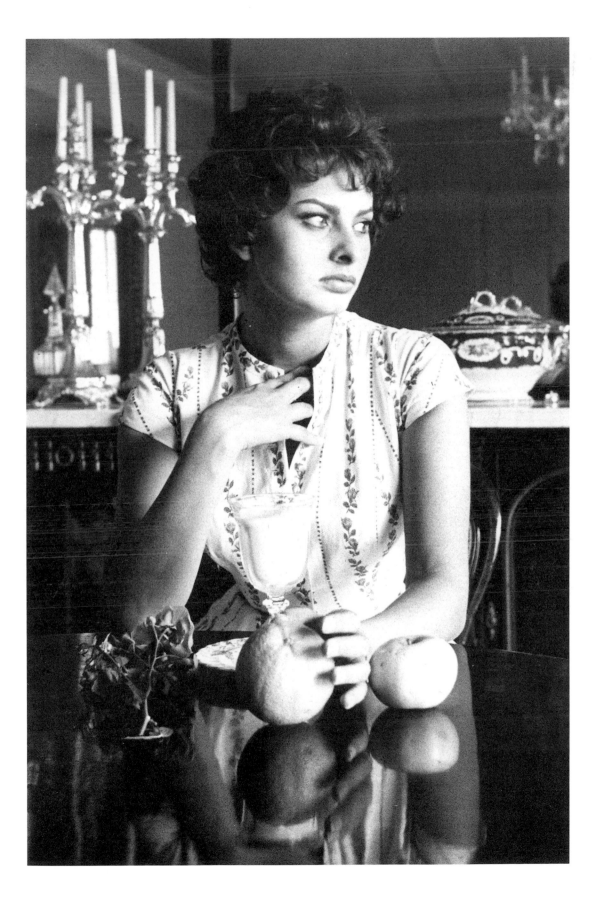

Sophia Loren

BRENTWOOD, CALIFORNIA

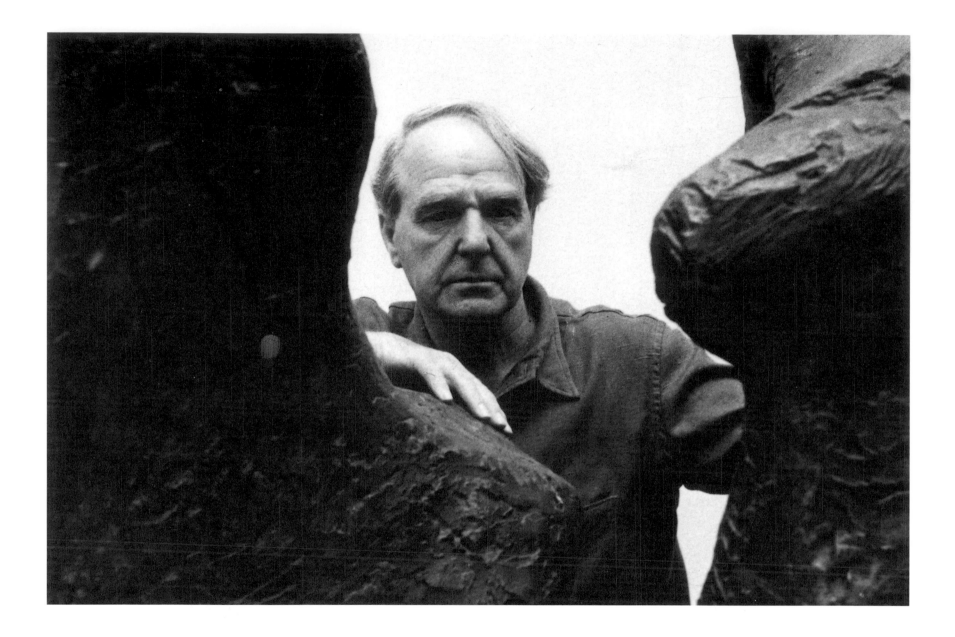

Henry Moore

MUCH HADHAM, ENGLAND

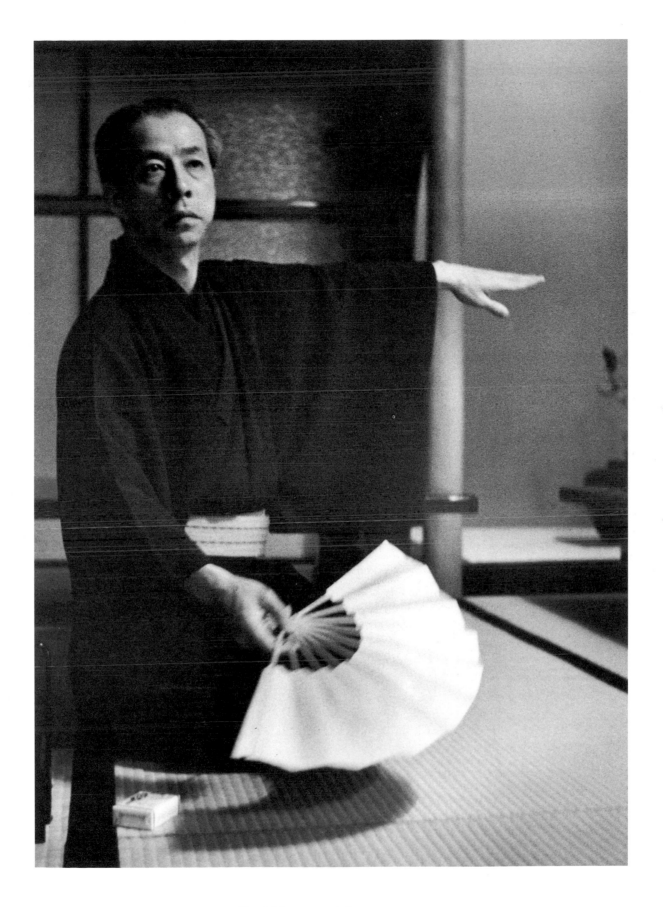

Fuijima Masaya

TOKYO

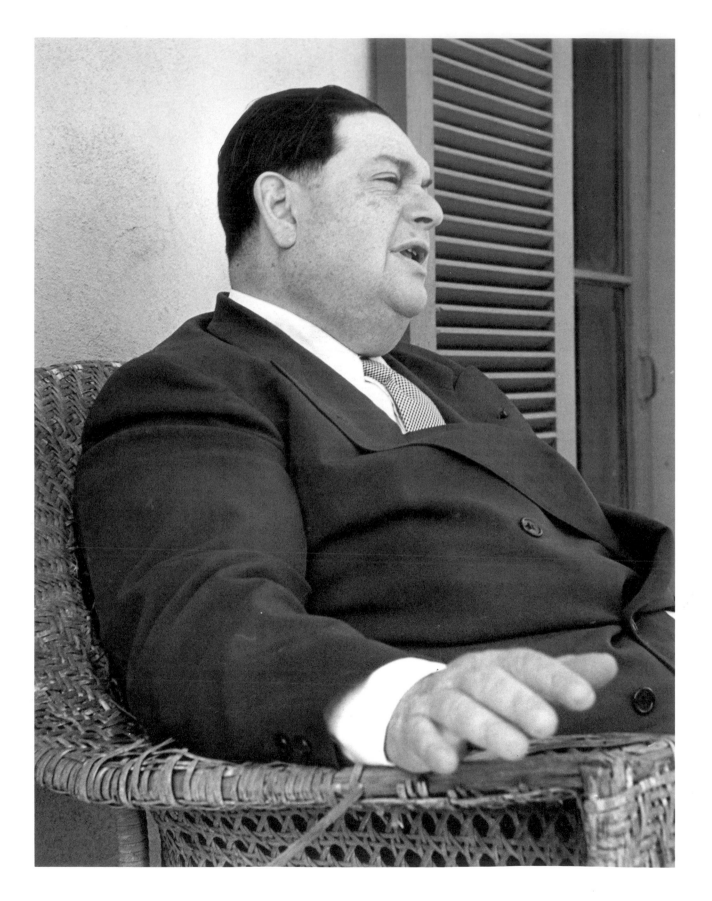

Darius Milhaud

OAKLAND, CALIFORNIA

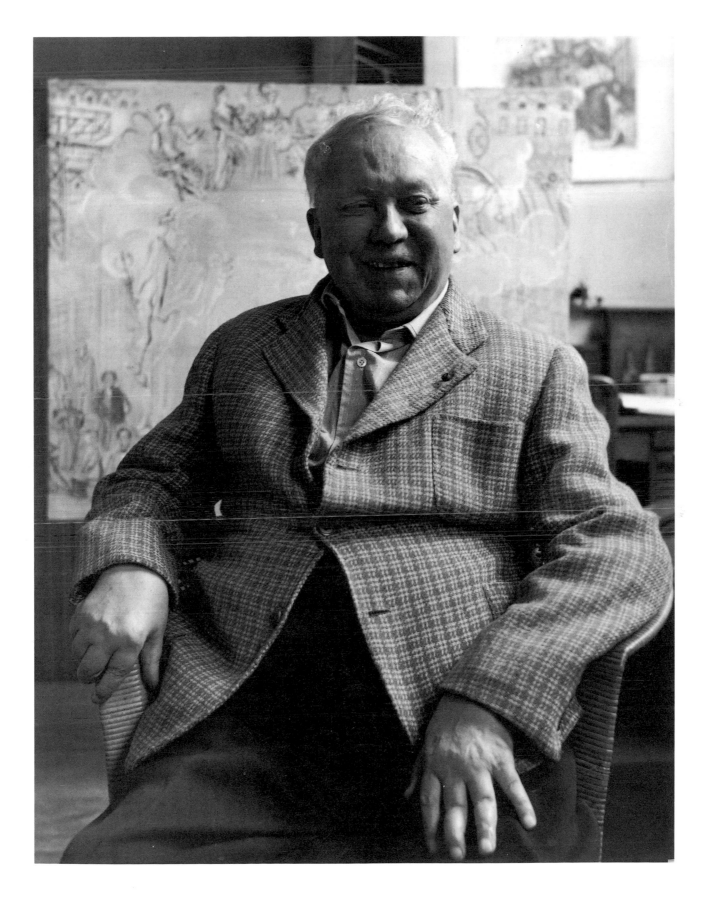

Raoul Dufy

PARIS

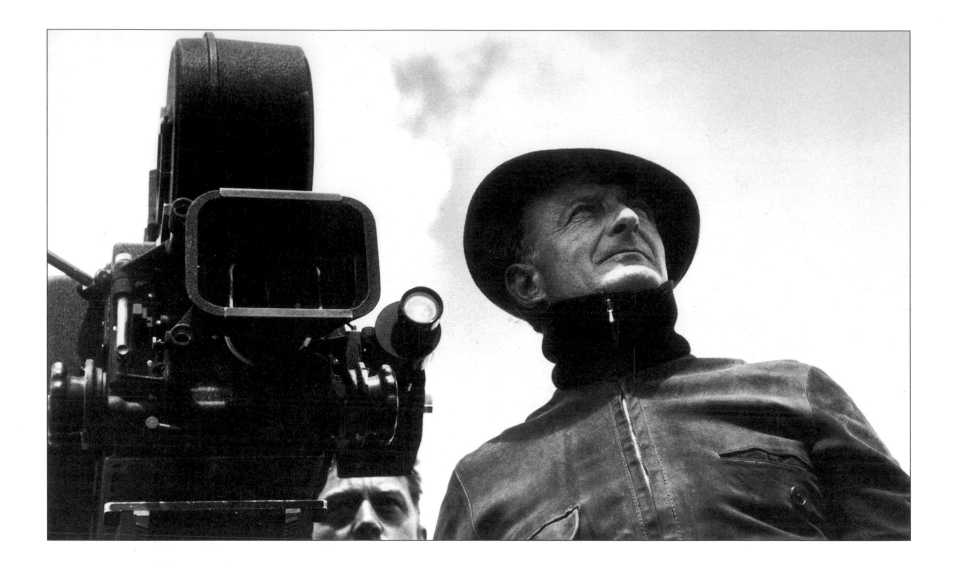

Fred Zinnemann

BELGIAN CONGO (ZAIRE)

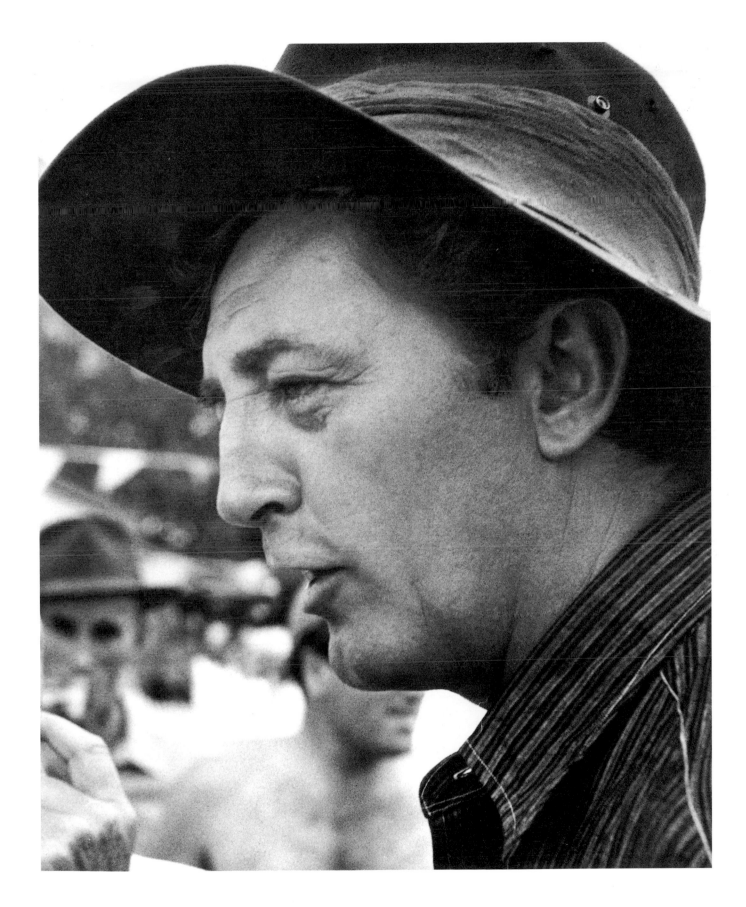

Robert Mitchum

AUSTRALIA

Gina Lollobrigida and Martine Carol

ROME

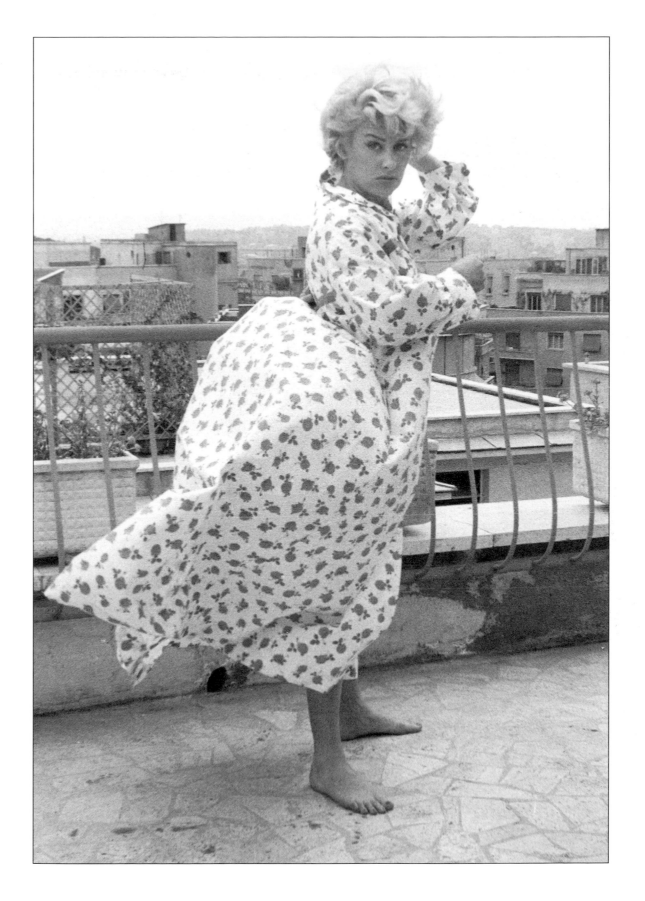

Martine Carol

ROME

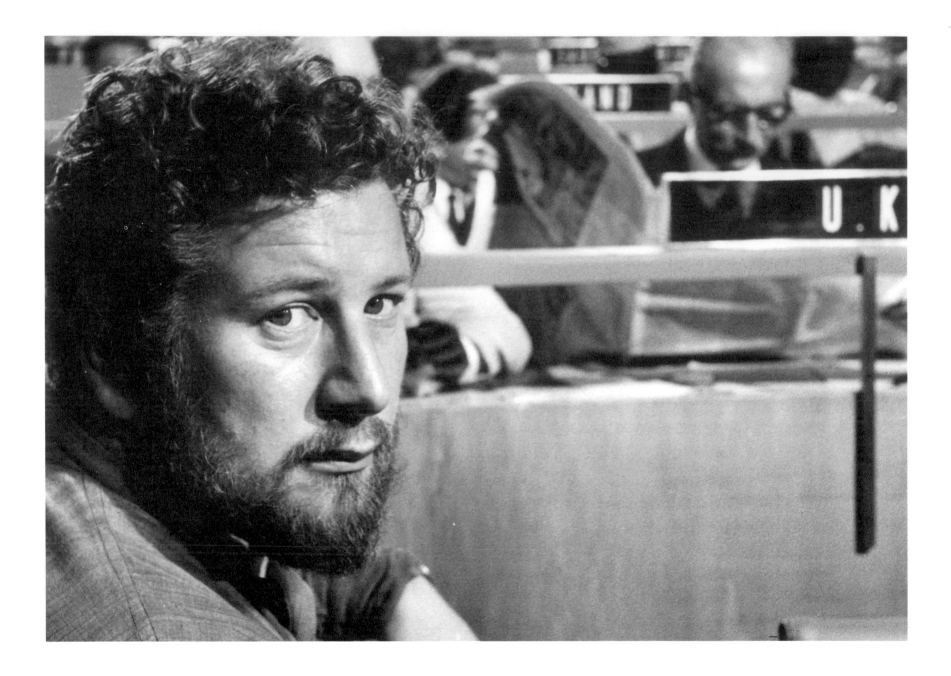

Peter Ustinov

TODI, ITALY

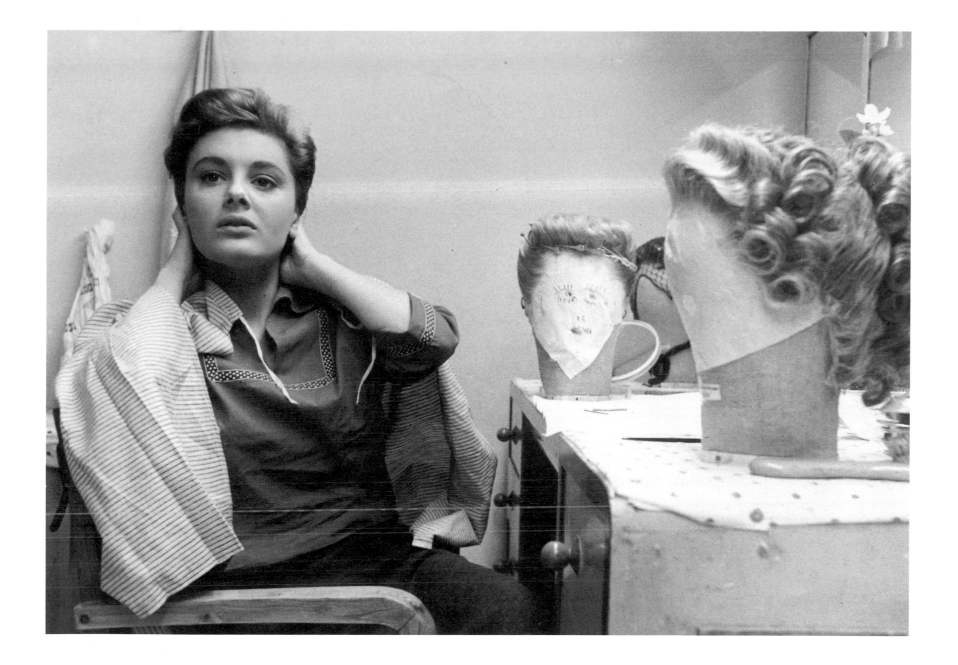

Rossana Podestà

ROME

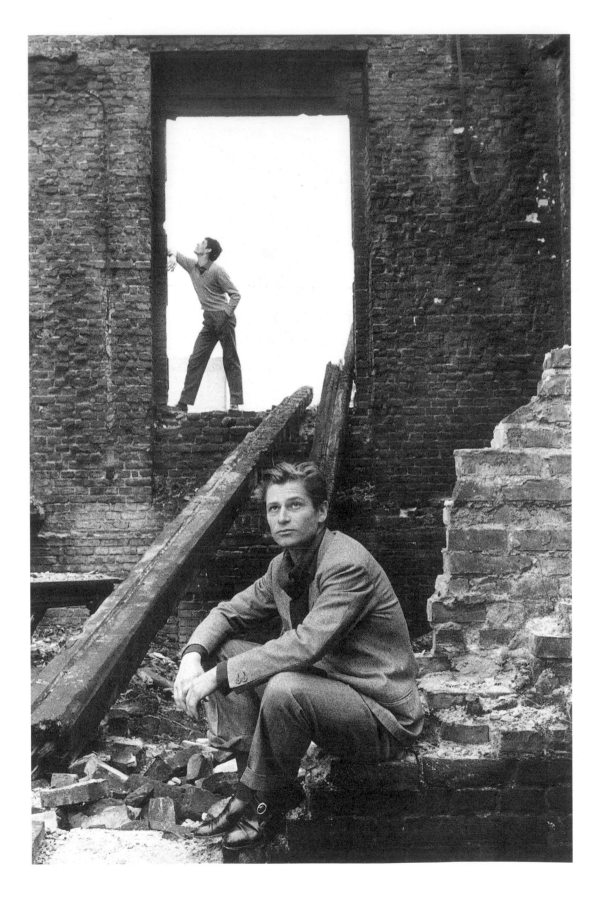

Jean Babilée

HAMBURG

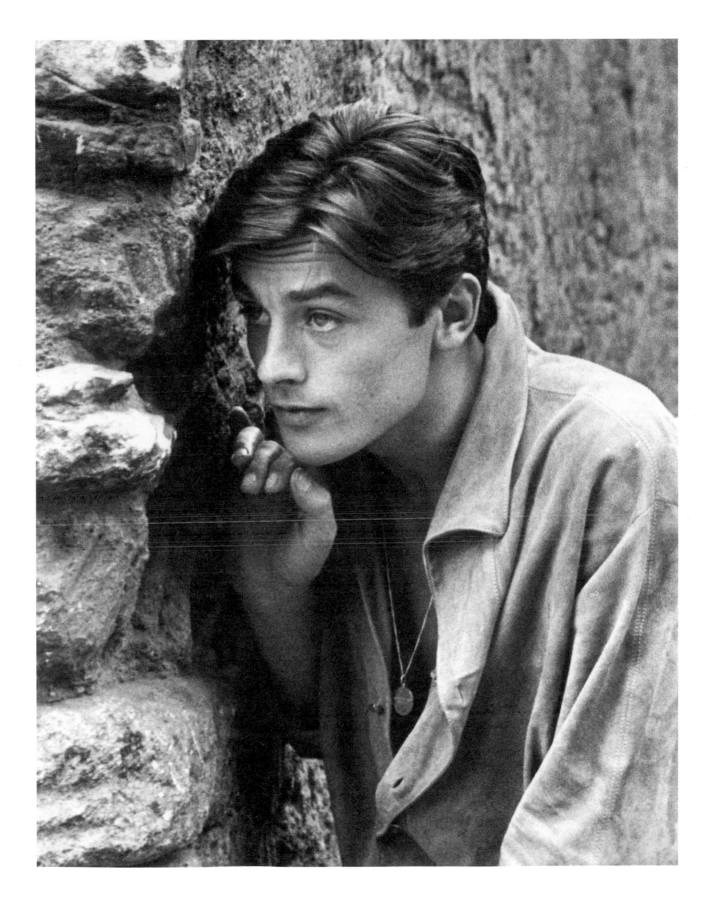

Alain Delon

ROME

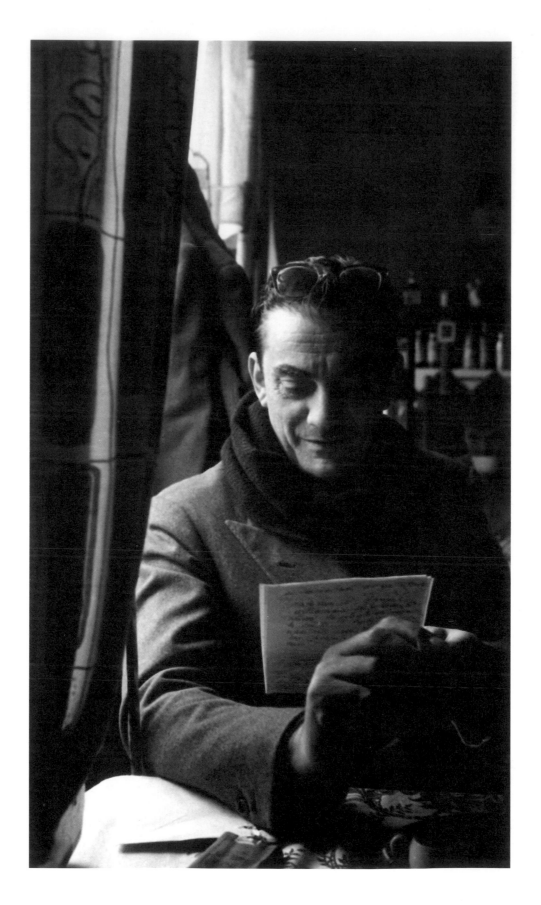

Luchino Visconti

HAMBURG

Monica Vitti and Alain Delon

OSTIA, ITALY

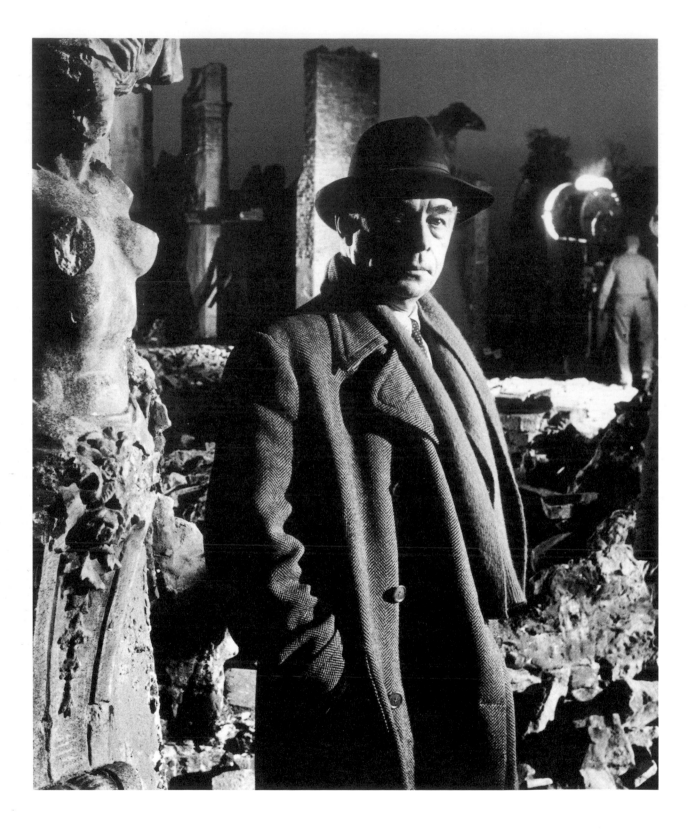

Erich Maria Remarque

BERLIN

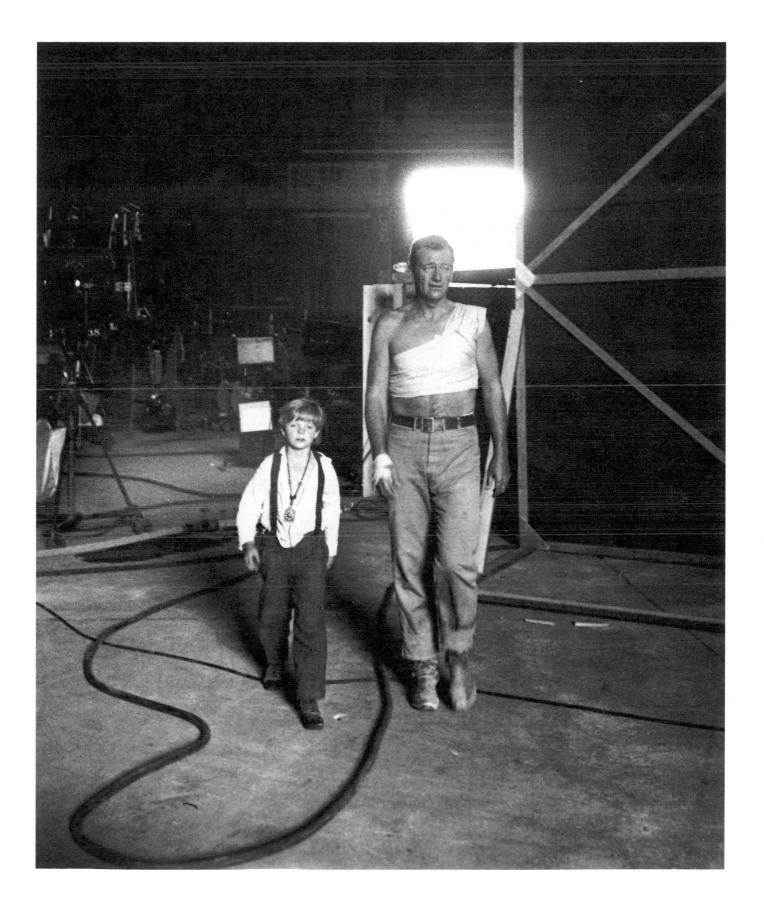

John Wayne

HOLLYWOOD

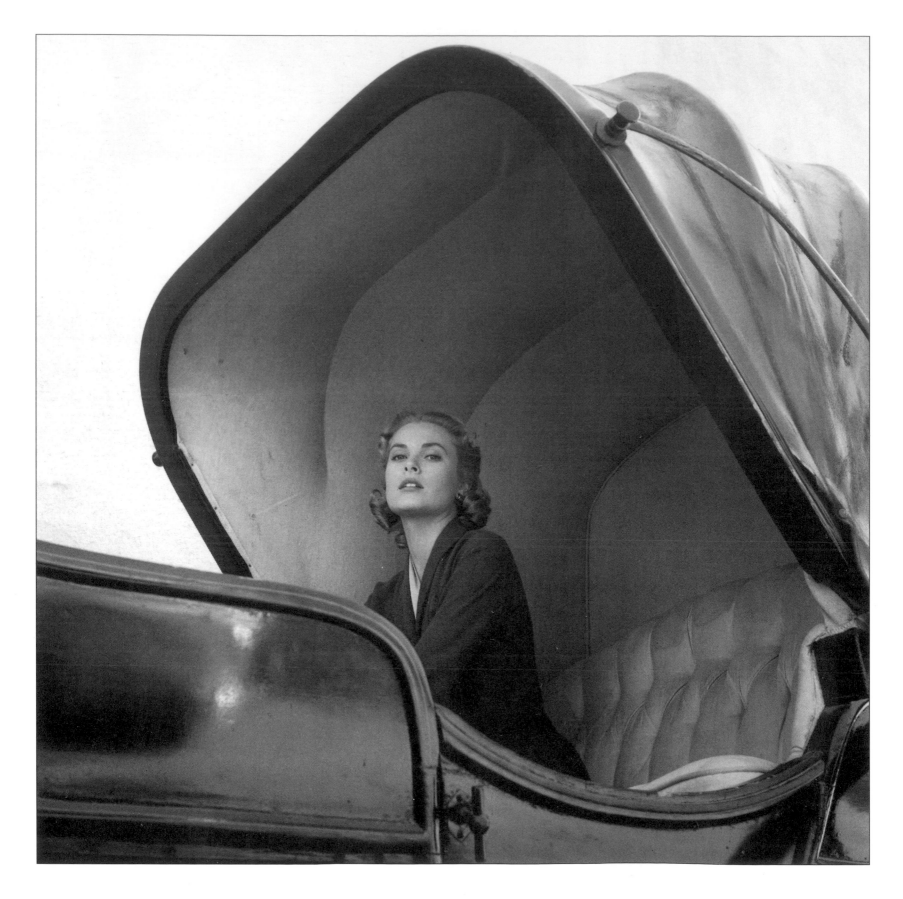

Grace Kelly

HOLLYWOOD

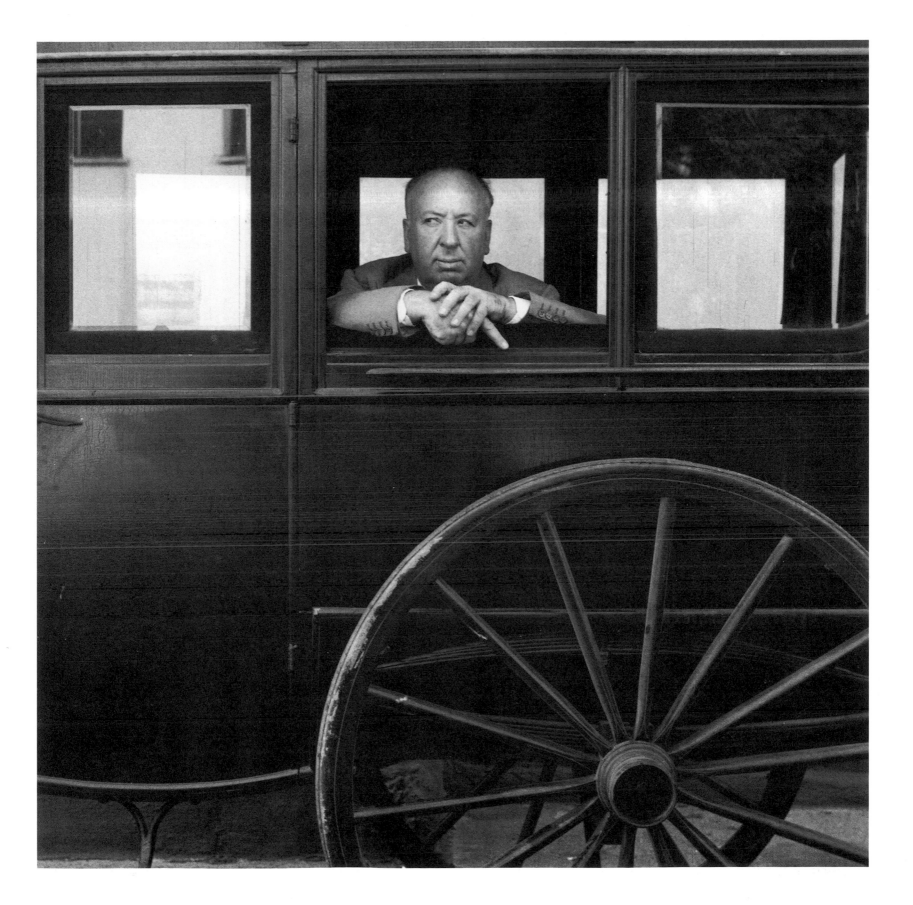

Alfred Hitchcock

HOLLYWOOD

Sanford Roth, Morocco.

Index of Photographs

This book was designed by Thom Dower, Los Angeles. The typeface is Futura. Typesetting was done by Archetype, Berkeley, California. The text paper is 128 gsm matte art, the cover stock is 260 gsm art board, and the jacket is 128 gsm glossy art. Printing and binding were done by South Sea International Press, Hong Kong.